YOUSUF KARSH
& JOHN GARO

THE SEARCH FOR A
MASTER'S LEGACY

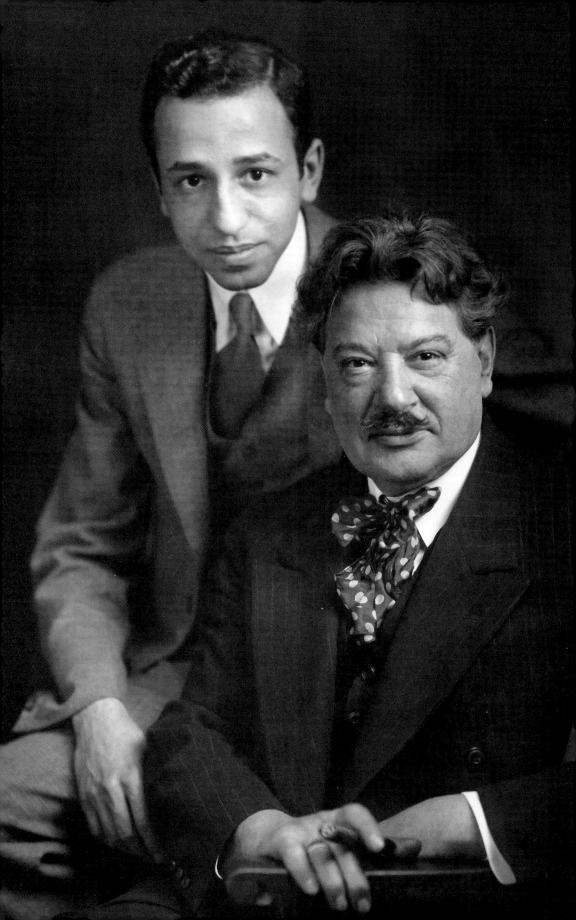

THE SEARCH FOR
A MASTER'S LEGACY

YOUSUF
KARSH

JOHN
GARO

BY MEHMED ALI

WITH AN INTRODUCTION BY
JERRY FIELDER

 BENNA BOOKS
A Boutique Press for Artists & Writers
Mansfield, Massachusetts

Dedicated to the victims of the Armenian Genocide

Published by Benna Books
Mansfield, Massachusetts
www.BennaBooks.com

Library of Congress Control Number: 2014958032

ISBN: 978-1-944038-00-7

10 9 8 7 6 5 4 3 2 1

Printed in China

CONTENTS

ACKNOWLEDGMENTS

The fleeting quality of fame is a well-known concept to any scholar of history. Recognition and renown can fade, just as an old-format photographic image will "wash out" through overexposure. A few names stand the test of time, but most are lost, except to those who knew the individual personally or who are devoted students of the individual's particular field.

Many nameless people have come and gone over the generations without leaving a legacy that is remembered. While we might recognize the famous kings and empresses and presidents of ancient days, who recalls the people who were not charged with such exclusive roles? Most of them, as unique and special individuals, have sadly vanished from memory and the printed record long ago.

In many ways, peoples' lives are comparatively short along the continuum of time, if not remembered. The written fragments, the miscellaneous patrimony, and the memories of photographer John Higue Garo have existed for some time now in a sort of suspended animation, uncontextualized, unordered, and uninterpreted. This book

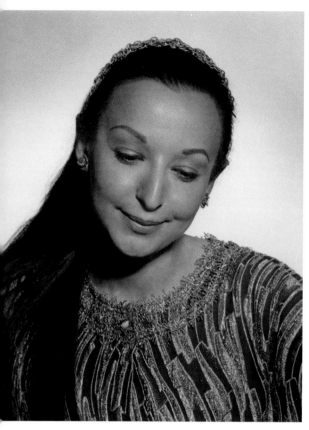

Estrellita Karsh, by Yousuf Karsh (1970)

seeks to redress the decades-long absence of a proper biography of John Garo, an important but neglected individual, and examines the relationship between Garo and his famous student, Yousuf Karsh.

I stumbled across John Garo in the smokestacked alleys of Lowell, Massachusetts, where I was trailing his brother Martin, who once lived there, for a separate project. I discovered that Garo had photographed Cardinal William O'Connell, the famous archbishop of Boston who sponsored my great-uncle, Bishop Tom Markham, into the priesthood. My interest in this relatively unknown, yet historically significant photographer was piqued, and I decided to write a short journal article about the man who mentored Yousuf Karsh.

As I sought more knowledge about John Garo, my first contacts were Aaron Schmidt of the Boston Public Library and Garo's great-nephew John Garo Eresian, who provided early, energetic, and friendly encouragement to pursue all the leads I could find. John and his late wife, Van, provided detailed and in-depth answers to many of my questions and never hesitated to help when I came back for more.

The Eresians advised me to approach Estrellita Karsh, Yousuf Karsh's widow. Her graciousness and generosity made Garo's biography a reality, and she gave me access to personal correspondence between her husband and Garo.

Jerry Fielder was tireless in his support for the project, guiding me throughout the process and providing solid advice on how to make the manuscript stronger. I'm indebted to his collaborative spirit. And great gratitude is owed to Jennifer Delaney for the professionalism she brought to the project, as she guided us through the long tunnel of getting this book published. Hers is the very patient path.

Several of John Garo's relatives welcomed me into their busy lives to provide me with information and clues to the next stop on my research trek. Marylyn Tomajan, Joan Gold, and Linda Bogosian were extremely helpful and kindhearted, and Bruce Papazian provided great company and a big basket of ideas over lunch at the Olympia Restaurant in Lowell.

The librarians, who were superlative in solving great repository puzzles, made me want to join their ranks someday. Among the "luminaries of the library" who deserve praise are the indefatigable Tony Sampas and my unfaltering second hand Janine Whitcomb of the University of Massachusetts, Lowell; Sally McKay of the Getty Research Institute; Gary Lind-Sinanian of the Armenian Library and Museum; Gwido Zlatkes at the University of California, Riverside, library; the George Eastman House's Barbara Galasso, Susan Drexler, and Joe Struble; Michael Rush of Yale University's Beinecke Rare Book & Manuscript Library; University of New Hampshire's Louise Buckley; and Romie Minor of the Detroit Public Library. Others to share thanks with are Anne Havinga and Patrick Murphy at Boston's Museum of Fine Arts; Gilman Shattuck of the Hillsborough Historical Society; Bangor Public Library's Patrick Layne; Nancy Burns of the Worcester Art Museum; Historic New England's Lorna Condon and Meghan Petersen; and Shannon Perich of the Smithsonian Institution. Sophie Tellier, Andrew Rodger, Madeleine Trudeau, Alix McEwen, Melanie Quintal, Stephanie Speroni, and Jill Delaney of the Library and Archives Canada/Bibliothèque et Archives Canada were

awesome in opening up a "closed collection," that had yet to be processed, as well as providing a most hospitable atmosphere for research.

Project SAVE Archives' Ruth Thomasian, on the photographic preservation prowl for decades, has assembled one of the most extensive collections of a particular ethnic group (in this case the Armenians) of anyone. Her dedication to saving history at the most personal level should serve as a model for other groups in the United States and around the globe. Along with Ruth, staff at the archives who provided key support for the project include Suzanne Adams, Aram Sarkissian, and Hasmig Esserian.

Others who assisted in digging up a few golden nuggets include Christine Cole, formerly of Crimson College fame; Peter Kostoulakos—restorer extraordinaire; John Curuby of the Boston Art Club; Elise Ciregna of Forest Hills Cemetery; Marc Mamigonian of the National Association for Armenian Studies and Research; John Kasaian; Ellen Lipsey of the Boston Landmarks Commission; William Young of the Back Bay Architectural Commission; Brian Welch at Harvard University; Nena Radtke of the Unitarian Universalist Society of Wellesley Hills; and Afrika Hayes-Lambe, the daughter of Roland Hayes.

One should not forget Dr. Hagop Martin Deranian, our guide to Massachusetts' Armenian legacy. His youthful inspiration is all one needs to keep working!

A heartfelt *ahr kuhn* goes out to Sivang Suos who, over a period of several years, greatly assisted me in various research endeavors from the Registry of Deeds in Nashua to a trip to Ottawa's Library and Archives Canada. Her positive spirit and smile will always be with me.

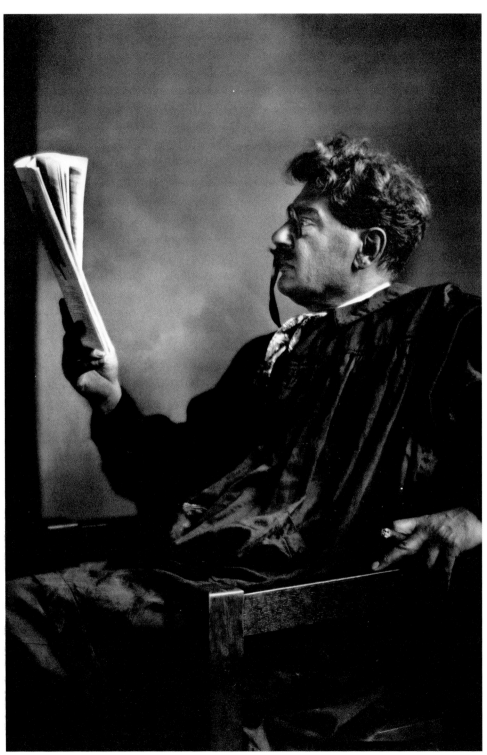

John H. Garo, by Yousuf Karsh (1931)

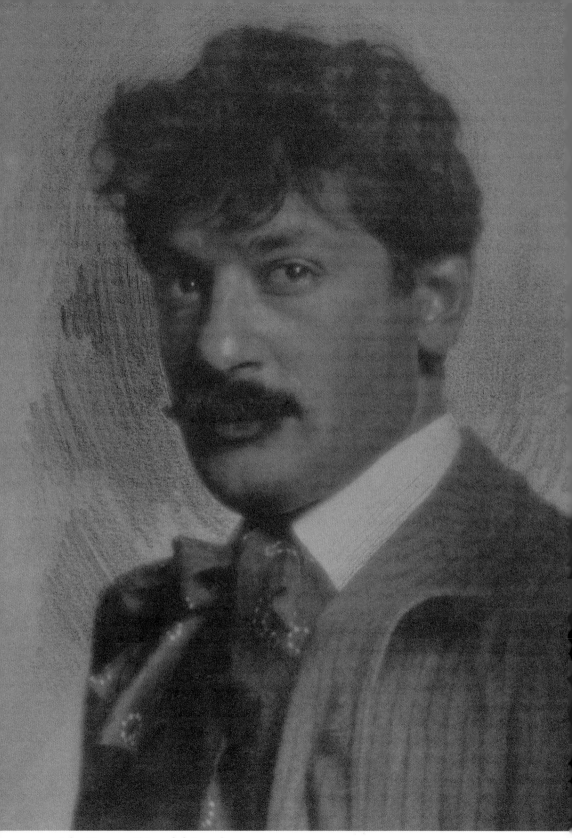

John Garo, artist and date unknown

Introduction
MASTERS AND MENTORS

Many people crossed paths with John H. Garo during his colorful and charismatic career. Some were celebrities, some were colleagues, some were friends, and a fortunate few were all three. One of those individuals privileged to become a member of the final category was a young Armenian immigrant who shared a common history with Garo. His name was Yousuf Karsh, and he came to Boston in 1928 at the age of nineteen to apprentice for six months with this great master of photography. Those few months turned into three years, which profoundly changed the accomplished and influential lives of both men.

Mehmed Ali has written an insightful biography of John H. Garo and of his journey from modest beginnings to a life as one of New England's most celebrated and respected photographers. As with so many distinguished artists who fall out of fashion, Garo is now almost forgotten, but Ali has done a great service in reminding us why Garo was so significant and influential during the late nineteenth and early twentieth centuries.

I would like to highlight the importance of the years Garo and Karsh spent together in Boston, and how this experience enriched

their lives and radiated out to influence many others, including me. To understand the impact Garo had upon Karsh and his future career, it is crucial to know something of his past.

Yousuf Karsh was born to Armenian parents on December 23, 1908, in Mardin, Turkey. Just seven years later the massacre began, when over a million Armenians in the Ottoman Empire were killed in what later became known as the Armenian Genocide. Life was tenuous for the Karsh family, and food was scarce. Each morning they woke unsure of what might happen and whether they would survive another day. Karsh's sister died a gruesome death, and two of his uncles were murdered—one thrown alive down a well and the other killed in prison.

In 1922, the Ottoman government gave the Karsh family permission to leave the country. They were ordered to dispose of their remaining possessions and to leave open the doors of their home, never to return. They spent a difficult twenty-nine days traveling by caravan to Aleppo, Syria. They had their freedom, but the price was high. It meant starting over with literally nothing.

Karsh later wrote, "Only those—and there are many in the world today—who have seen their life savings destroyed and have rebuilt them from nothing can understand the spiritual resources that must be drawn upon in such conditions."

The family was eventually able to send Karsh to join his uncle, George Nakash, a photographer in Sherbrooke, Québec. He assisted his uncle in the studio, and soon after he started working with the cameras and the processing chemicals, he became fascinated with photography in general and portraiture in particular.

As Karsh's interests developed, Nakash gave him an inexpensive camera with which he could experiment. It was with this camera that he took *Landscape 1927*, his earliest photograph still in existence.

Karsh presented a print of this study to a friend who had been kind to him. Without informing Karsh, the friend entered the print in a

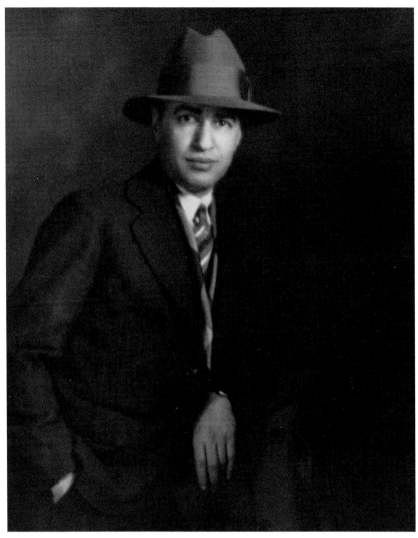

Self-portrait, by George Nakash (1932)

photography contest and won first place, which came with a cash prize of fifty dollars—no small sum in 1927.

More important than the monetary award, the recognition gave Karsh a newfound confidence in his work. At the same time, his uncle realized that Karsh deserved greater opportunities to nurture his talent. Wanting to expand his nephew's options, Nakash corresponded with his good friend John H. Garo in Boston, and in 1928, Karsh moved yet again to another country, the United States.

Early Landscape, by Yousuf Karsh, (1927)

In his memoirs Karsh recalled, "Of all my many debts to Uncle Nakash, his persuading Garo to accept me as an apprentice is the one I have least been able to repay."

George Nakash, a talented photographer himself, had recognized Karsh's natural gift for composition and his understanding of light, but it was Garo who would shape and hone those strengths and guide them to a higher level.

Graham Greene, who later became one of Karsh's subjects, wrote, "There is always a moment in youth when the door opens and lets the future in." Such was the moment for young Yousuf Karsh when he arrived at 739 Boylston Street, the entrance to John Garo's studio.

When they met in 1928, Garo was fifty-three and had long before experienced himself what Karsh, as a young immigrant and outsider, was undergoing at the time. Nevertheless, they both possessed an innate positive attitude that propelled them forward. They had seen the worst life had to offer, and it had only increased their appreciation for the best.

In 1937, just two years before he died, Garo was quoted in the *Boston Herald*: "I have enjoyed every minute of my life. Photography is my vocation and I love it because I find in it the medium to interpret the art of painting, the art of music, the art of classical literature. But greatest of all, it is my canvas for the fine art of living. Art is everywhere if one can see, hear or feel it. But most of all, it is in life."

This passionate optimism,

Yousuf Karsh (detail of photograph on title page), by John Garo (circa 1929)

"Portrait," by John Garo, **Photo-Era: The American Journal of Photography** *(March 1906)*

devotion to work, love of art, and appetite for life had a lasting impact on Karsh. Garo's philosophy resonated deeply with him and provided him with a path for the future.

There were daunting lessons to be learned, but Karsh was a passionate, motivated student. Many photographers are great artists but poor technicians. Many are accomplished technicians but inferior artists. It is surprising how few photographers are gifted artists and master technicians, but Garo was both. Talent, which Karsh already possessed, is innate, but technique can be taught, and in his three years of study under Garo, Karsh became a superb craftsman whose skill in the darkroom still inspires awe.

Karsh's education under Garo went beyond photography. Some of the lessons learned involved psychology. Karsh wrote in his memoirs, "One of Garo's great gifts was his ability to fascinate, to enchant the subject to such an extent that the latter was really unaware of the act of photographing. When Garo held the bulb behind his back, the subject's interest centered on whatever Garo focused it upon." Karsh might just as well have been writing about himself, because he adopted the same technique, the same approach to the subject.

I assisted Karsh in hundreds of sittings, and when he was creating

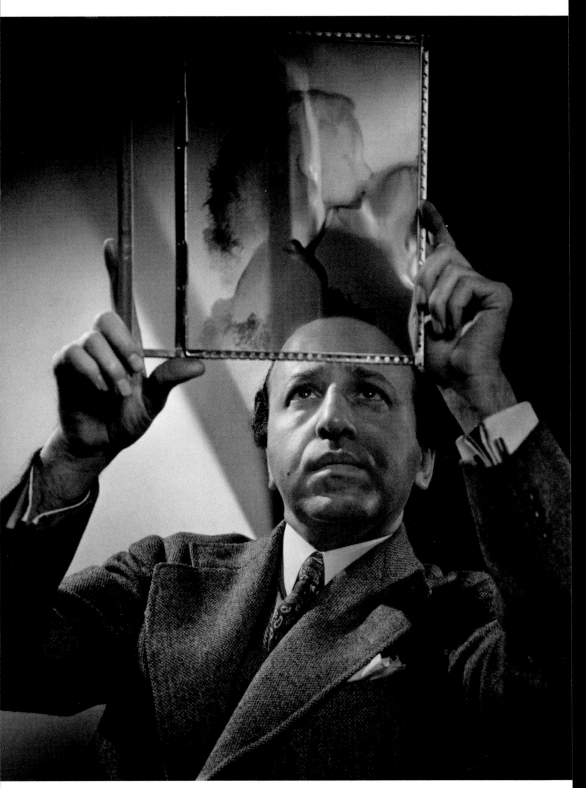

Self-portrait, by Yousuf Karsh (circa 1952)

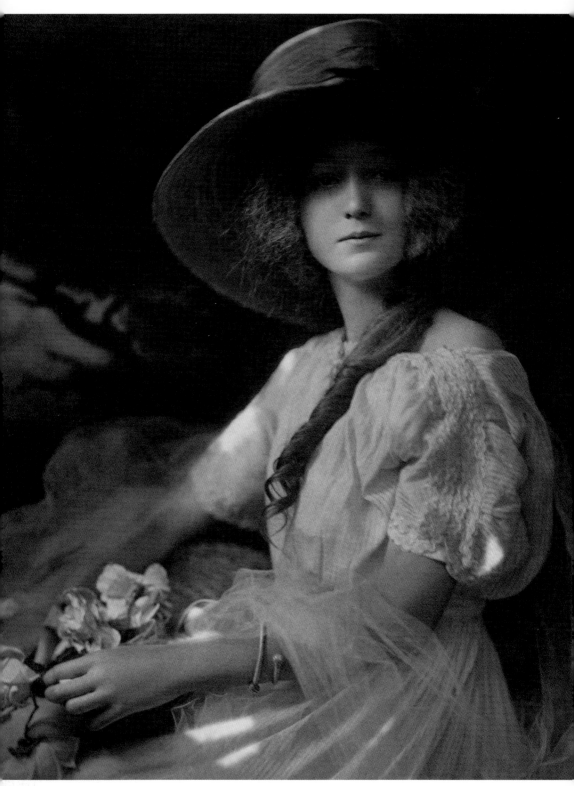

"Untitled," by John Garo, **Yearbook of the Photographers' Association of New England,** *Bridgeport Convention (1911)*

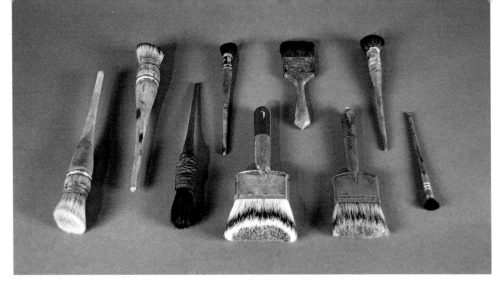

Karsh's collection of Garo's photographic brushes

a portrait, his concentration and his focus on the person before him were absolute. The rest of the world ceased to exist, and sitters felt the strong pull of his attention. It was a lesson well learned from Garo.

There was a locked cabinet in the Karsh Studio that contained Karsh's most precious negatives. Next to them was an old cardboard box, carefully wrapped and tied with faded twine. It contained the brushes and darkroom tools used for Garo's bromoil, platinum, carbon, and gum arabic prints. It was a treasured reminder of Garo's skills, and Karsh's deep reverence for the man.

After Garo's death in 1939, Karsh spent decades searching for Garo's original prints. The author follows that fascinating trail in this book. In spite of Karsh's exhaustive efforts, only a few tantalizing Garo original photographs remain. They have found good homes at the Museum of Fine Arts, Boston; the Library and Archives Canada; and the Fogg Art Museum at Harvard University. We are fortunate,

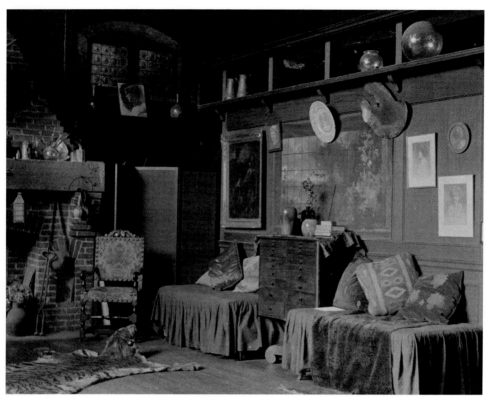

Corner of John H. Garo's studio (1931)

however, that several important journals of photography survive that provide a richer and more detailed document of his talent and his art.

While Karsh certainly learned a great deal in Garo's studio, he absorbed still more in Garo's salon once the sun had set. The studio used only natural light for photographing subjects, and Karsh often told me stories of lively evenings in the studio.

Garo's salon was a gathering place for the cultural and artistic community of his time. Such evenings were a wondrous new experience for Karsh—full of stimulating company, intelligence, and glamour.

Years later he wrote, "I was able to share in wonderful conversations and study some of the great personalities in the world of music, letters, theatre, and the opera of the 1920s. It was an opportunity for me to listen to wise men and brilliant women conversing. Those were glorious afternoons and evenings, and I knew them to be so even at

the time. Garo's salon was my university, a noble institution at which I had been permitted to study."

John Garo was a renaissance man with many colors on his palette. He was an accomplished painter who embraced the modern age to become an extraordinary photographer. He was a rakish raconteur. He was dapper with more than a dash of dandy. He was an aesthete but also an athlete. He was an intellectual with an uninhibited sense of fun. He was impulsive at parties but took his friendships seriously. He was above all an artist with a palpable love of life and a focused devotion to his work.

Interestingly, all of these qualities, except for the painterly skill, were just as true of Karsh. It wasn't so much that Garo passed them on to his eager apprentice. It seems, rather, that they were already there and that Karsh found in Garo a kindred spirit and admirable example of how he wanted to live his life.

Such were the various and major ways Karsh benefited from his time with the great man, but Garo also discovered something life-changing and profoundly rewarding in his young apprentice. Garo was childless, but in Karsh he found a surrogate son and more. He found someone who truly understood his work, who respected his talent and techniques, and who would be forever appreciative for the lessons learned. He also found a person who loved him both as an artist and as a father figure. That love never ended, and when Karsh would talk to me about Garo, his eyes would often tear up with affection and gratitude.

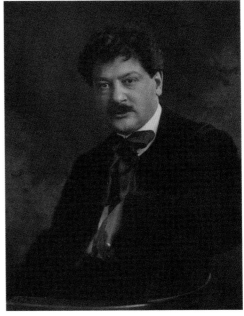

Self-portrait, by John Garo

None of this is to say that Karsh as a photographer was a replica of his mentor. Garo was from a pictorialist tradition, and his photographs were often soft-focused and romantic. Karsh's photographs were more theatrical, with sharper definitions and stronger contrasts between the blacks and whites. Their artistic paths were different, but their approaches were the same—careful composition, attention to detail, communication and connection with the sitter, technical acuity, and an understanding of the power and playfulness of light.

Oscar Hammerstein and Stephen Sondheim, who were both photographed by Karsh, enjoyed a mentor-apprentice/father-son relationship similar to Garo and Karsh. In a 2014 documentary, Sondheim said, "If I was going to ask for professional standards, he was going to treat me like a professional. My style is entirely different from his. He

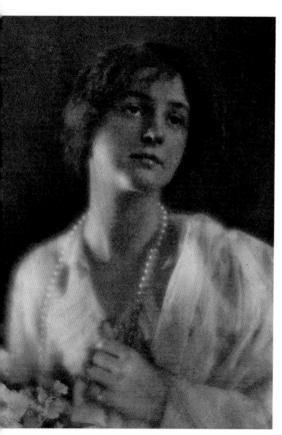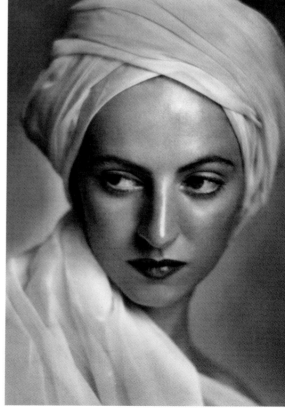

"Simplicity," by John Garo (1915) and "Turban," portrait of Betty Low, by Yousuf Karsh (1936)

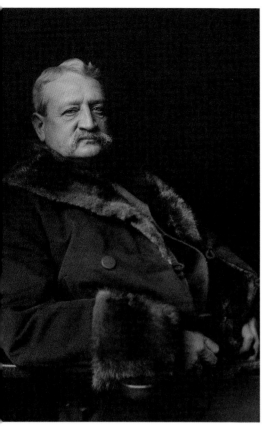
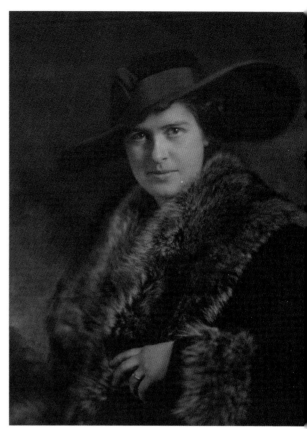

Unknown subject (circa 1914) and Gladys Harlow Tomajan, both by John H. Garo

told me not to imitate him. If you write what I feel, it will come out false. If you write what you feel, it will come out true."

Sondheim learned to build on the foundation Hammerstein gave him, and to go in a new direction. But the immeasurable gift was that his foundation was based on what he learned from a master. This lesson was just as true for Karsh in photography as it was for Sondheim in music. Near the end of their time together in Boston, Garo told Karsh, "If you copy me, you will have learned nothing."

Karsh became a mentor himself, in varied and sometimes unexpected ways. Not long after Karsh died, his wife, Estrellita, told me about a memorable call she received from a middle-aged man in Ohio whom she had never met. This gentleman had discovered photog-

Yousuf Karsh, by Ivan Dmitri (circa 1965)

raphy when he was fifteen and had decided to quit high school to travel the world and take pictures. His mother vehemently opposed the idea, but he felt it was his destiny.

One day, he and his mother were in an American Airlines lounge awaiting a flight to visit relatives. Karsh, the boy's photographic hero, happened to be in the lounge as well, awaiting a flight to a different city. The boy's mother recognized Karsh and told her son to go over and talk to him. The boy was too shy, so his mother went over instead. Much to the boy's horror, she placed her hands on her hips and told Karsh her son wanted to quit school. She said this was partly Karsh's fault and asked, "What are you going to do about it?" A surprised Karsh asked to speak with the boy privately. As they began to talk, an airline representative came to inform Karsh it was time to board the plane. He looked at his watch and asked if there was space available on the next flight. The man recalled Karsh saying, "My colleague and I are discussing serious matters." The gentleman told Estrellita, "When I heard the word colleague, I was flabbergasted! Imagine this great master putting us both in the same category!"

Having been married to Karsh for over forty years, Estrellita was intrigued but not entirely surprised. She asked the man, "What did he

say to you?" And the gentleman went on, "Mr. Karsh told me I was fifteen years old, and that I had fifteen-year-old eyes. And if I quit school now, I will always have fifteen-year-old eyes, and my horizons will be fifteen-year-old visions. He said, do not quit school. Instead, he said to study art, study music, study history, study literature, study poetry, and continue to take photographs and graduate from high school and then college. Then, and maybe then, you will take a photograph that is a work of art. But that it doesn't matter—your life will be enriched and your vision will be extended in the process. He said to continue

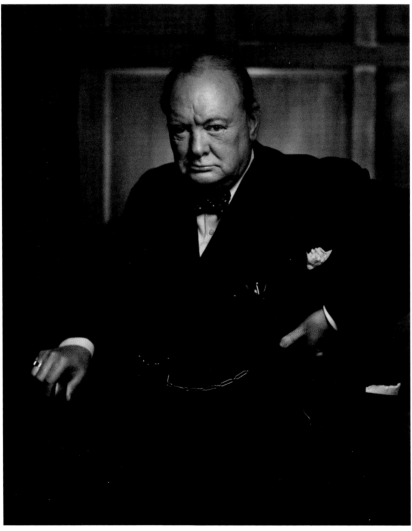

Winston Churchill, by Yousuf Karsh (1941)

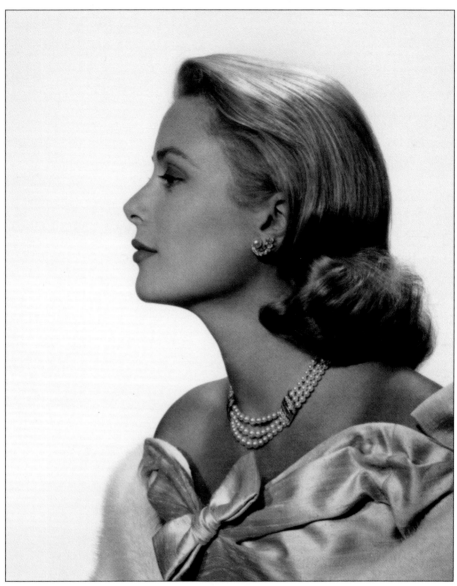

Princess Grace of Monaco, by Yousuf Karsh (1956)

with your passion. Even if you decide not to become a professional photographer, you will at least be a well-rounded human being, ready to live in the world."

The gentleman told Estrellita, "That day changed my life. I followed Mr. Karsh's advice, and today I have a successful portrait studio. I just wanted you to know the effect a one-hour conversation, in an airport, had on a very stubborn and impressionable young man."

When young photographers came to the studio to show Karsh their work, he would give them his full attention, but even more importantly, he would give them honest appraisals of their work. He always took care to emphasize their strengths, but he felt it was better to be honest than patronizing. These were people making life-changing choices about their futures, and he took the responsibility very seriously.

At times Karsh influenced photographers in nontraditional ways.

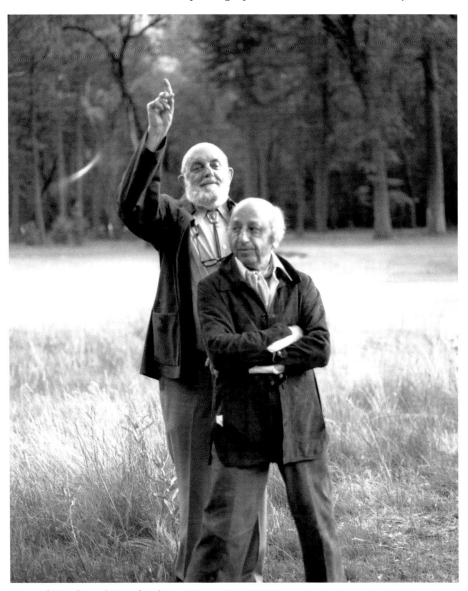

Yousuf Karsh and Ansel Adams, Yosemite (1977)

In 1978, he and his friend Ansel Adams gave a joint workshop at Yosemite, and two young photographers, Bob Kolbrener and John Sexton, both of whom went on to have distinguished careers, were part of the group.

Kolbrener recently recounted to me a distinct memory of Karsh: "By the mid-1970s, photographers in general viewed themselves as

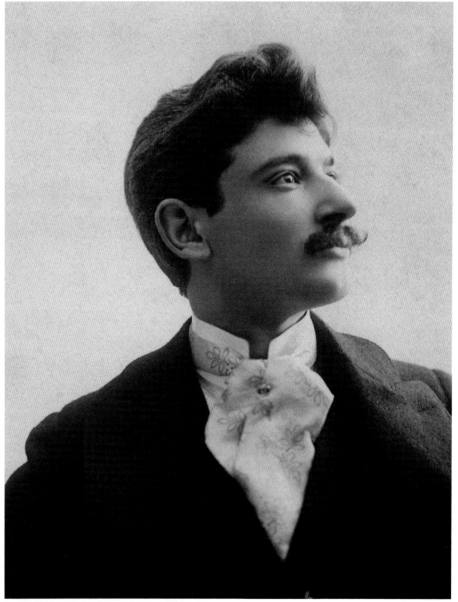

Self-portrait, by John Garo (circa 1890)

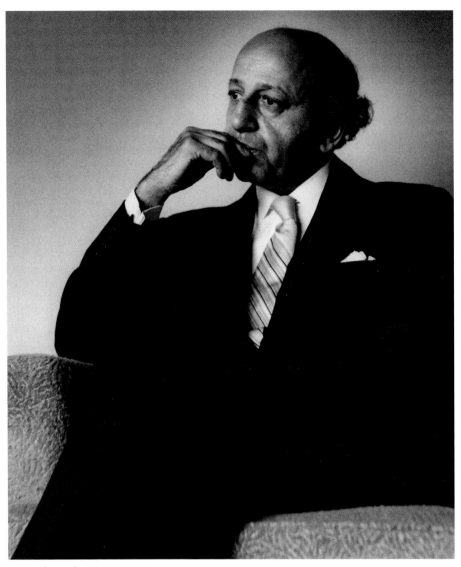

Yousuf Karsh (circa 1970)

'artists,' which translated to bohemians. Yousuf was a gentleman, as well as a great photographer. That was most impressive to me and still influences how I present myself as a professional."

As a photographer, when you engage in making portraits, how you present yourself to others affects their reaction to you. This was a lesson Garo understood and passed on to Karsh, who in turn passed it on to Kolbrener. It served all of them very well.

In 1979 Karsh hired me to come from my California home to be his photographic assistant in Ottawa, Canada. When we closed the studio in 1992, I became his curator; and when he died in 2002, I also became the director of his estate, positions I still hold today. When we began working together, I didn't expect to find a career, much less a mentor who would have such a profound effect on my life. And when I say mentor, I do not mean in the conventional sense of teacher and

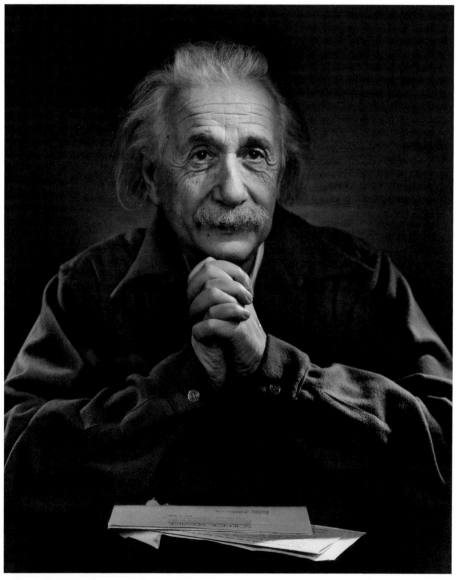

Albert Einstein, by Yousuf Karsh (1948)

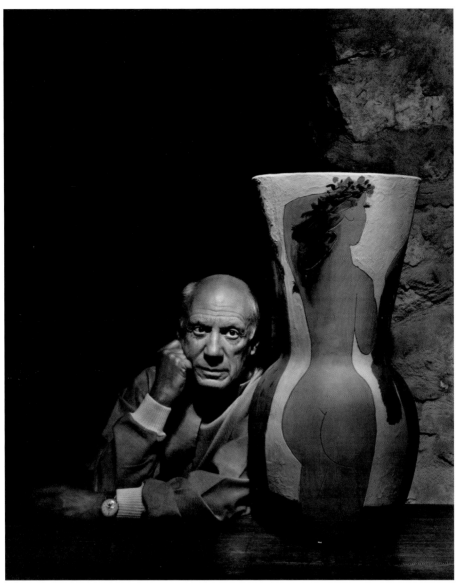

Pablo Picasso, by Yousuf Karsh (1954)

student. Like Garo and Karsh, we became not only colleagues but also family.

What I learned from Karsh I learned by example, and the lessons went beyond the technical aspects of photography. I observed his respect for people and his capacity for listening to them. Karsh was impressed by talent, intelligence, humor, and accomplishment. But most

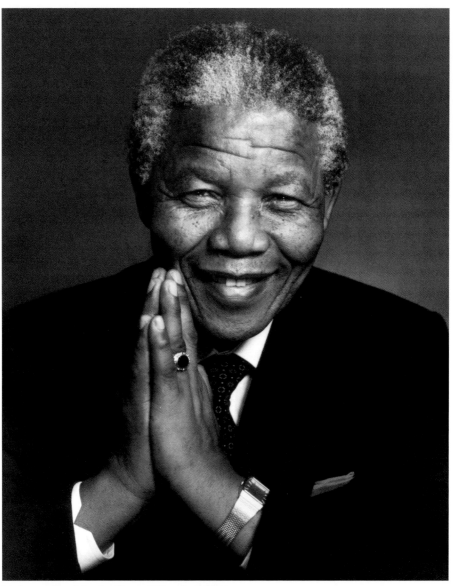

Nelson Mandela, by Yousuf Karsh (1990)

of all, he was impressed by kindness and integrity. He treated everyone
the same, whether they were a headwaiter or a head of state. When
you were with Karsh, you felt as if you were the most important person
in the world because his focus was entirely upon you.

Many of the public figures he photographed were accustomed to
flatterers and sycophants and were well acquainted with insincerity.

When they met Karsh, they recognized a person who was genuine, which gave them the freedom to be themselves. For this reason, his photographs still resonate today, revealing fundamental truths about his subjects, a lesson he learned from John H. Garo.

Garo himself photographed or knew many of the great figures of his age, including President Calvin Coolidge, John Singer Sargent, Edward Curtis, Billie Burke, Edward Weston, Enrico Caruso, Arthur Fiedler, Ethel Barrymore, Edward Steichen, Alfred Stieglitz, and George Eastman.

Karsh carried on this tradition to become one of the most respected and accomplished photographers of the twentieth century. He gave us the iconic portraits we collectively remember of such diverse cultural personalities as Winston Churchill, Pablo Picasso, Albert Einstein, Ernest Hemingway, Fidel Castro, Nelson Mandela, Bill and Hillary Clinton, Mother Teresa, Muhammad Ali, Pablo Casals, Ronald Reagan, Audrey Hepburn, Walt Disney, Frank Lloyd Wright, Andy Warhol, John and Jacqueline Kennedy, and Queen Elizabeth II.

Karsh achieved a level of fame and success that far exceeded Garo's, and he is often referred to as a master. In truth, as this invaluable biography demonstrates, they both were.

JERRY FIELDER
Curator and Director
Estate of Yousuf Karsh

Portrait of John H. Garo taken at Purdy Studio, 146 Tremont St, Boston

Chapter 1

APERTURE

Ottoman Armenia was a place of tragic precedent. Too numerous are the stories of generations caught up in waves of political and social unrest, which resulted in disaster. And yet among the many lost and forgotten, there are stories of individuals who persevered.

During the nineteenth century, the declining Ottoman Empire was exposed to foreign influences on a grand scale. Imports from Europe and North America changed the structure of commerce, and new transportation systems brought goods from the hinterlands into the world market. At the same time novel ideas were disseminated widely, from the western cities into the eastern provinces where the Armenians had lived for centuries.

Christian missionaries from New England found a willing partner in the Armenian people, who were interested in sharing knowledge with foreigners and being exposed to new ideas about education. So many Armenians began to accept the Congregationalist teachings that they became known as the "Yankees of the East," and communities were divided between the traditional Apostolic Church and the new "Protes" or "Prods." A theological seminary opened in the central

Anatolian city of Kharpert in 1859 with the goal of training local Armenian men to become Protestant pastors. And within a few more years, the Americans reached out to other areas of Kharpert province, including the village of Hoghe, where the missionaries established a school and, by 1867, a Congregationalist church.[1]

The village of Hoghe, "whose very name meant 'of the soil' or 'made of the earth,'" was located near the city of Kharpert (or Harpoot) with a population of 2,400 split evenly between Armenian and Turkish residents. In the village lived a young man, the son of five generations (some said five centuries) of ecclesiastical leaders, all belonging to the Armenian Apostolic faith. His name was Hovhannes Krekorian and he was described as "a remarkable personality." With his wife, Nonig, their family grew over time to include two daughters, Margaret and Mary, and three sons, Martin, Mikhail, and Mgurdich (an old Armenian name for John the Baptist).[2]

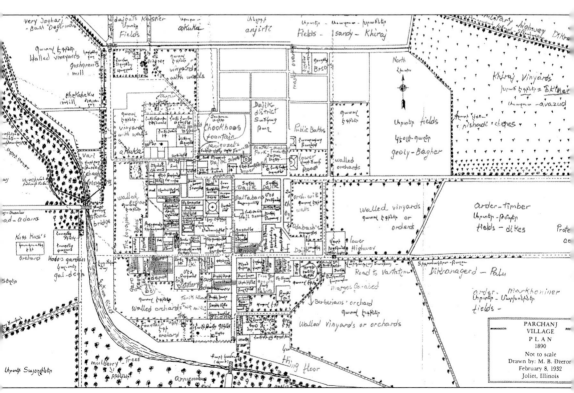

Map of Parchanj as it was in 1890, by Manoog B. Dzeron (1932)

Hovhannes became interested in the "new religion" that was being promoted in the region as well as the educational opportunities the missionaries were offering. He attended the Protestant seminary in Kharpert until 1876, when he was called up early to fill an open ministry in a church in the village of Parchanj. Around this time, Hovhannes changed his last name from the very traditional Krekorian (son of Gregory) to Garo (Charles), probably in a nod to the Protestant faith. Reverend Hovhannes and the family moved to Parchanj, a village of approximately 3,500 residents, with Armenians representing about three-fifths of the community. For nine years Hovhannes was the Protestant pastor of Parchanj and was described as "a natural orator, modest, well-informed and broad-minded."[3]

Parchanj was an idyllic place situated along what was called the Ertum River. Mulberry trees surrounded the area, and the village included two mosques, two churches, numerous vineyards, several fountains, and a public bath. The reverend was well known in the community and worked to broaden an understanding of the Protestant religion not only among fellow Armenian Christians but among the Muslim population as well. It was Hovhannes's drive and openness that led him to be invited by the Turkish community to give a lecture before the mosque one Friday. Here "he discoursed to them in the open on theological and philosophical topics," and observers related "how incredible it [was] . . . that such a thing ever happened." Many of Parchanj's residents came to see Hovhannes as "the most popular Prod preacher of the village."[4]

Given the long-held family custom of ecclesiastical service, Hovhannes's sons were expected to enter the church. The eldest, Mikhail Hovhanessian (son of Hovhannes), became a pastor and had a dynamic career in community activism serving as a national field worker for Armenian causes. He became the standard-bearer of family traditions and a model to the rest of the family.[5]

In regard to ancestral tradition, however, the second-born son, Mgurdich Hovhanessian, "didn't have time for that stuff." Mgurdich was more of a free spirit and took an interest in art as a child rather than religion. At the age of four, he was emboldened to practice his love of portraiture with a piece of charcoal on the freshly painted white plaster walls of his home. While some versions of the story relate that his actions caused "considerable domestic consternation," Mgurdich's account differs: "Funny my father or mother never said a word to discourage me—only by their faces did I know it was not quite right to do it." At some point after 1877, Mgurdich was sent back to Kharpert to attend Armenia College, an American-sponsored school incorporated in Massachusetts. Here he continued his studies and showed promise as a painter in his art classes.[6]

Meanwhile the political stability of the Armenian community weakened with the continued decline of the Ottoman Empire. With the Sublime Porte's defeat in the Russo-Turkish War, the position of the Armenians worsened as an era of repression began under Sultan Abdul Hamid II. The government persecuted teachers, encouraged the settling of new populations into traditional Armenian lands, imposed unfair taxes, imprisoned Armenian leaders, and even objected to the name of Armenia College, which was changed to Euphrates College.[7]

Armenians from Kharpert ("Kharpertsi") began immigrating to the United States to find new opportunities, including Mgurdich's brother-in-law, Marderos Sarkis Tomajan Nahigian. M. S. T. Nahigian was one of the first pioneers to move to Worcester, Massachusetts, which attracted so many Armenian settlers it later became known as "Little Kharpert." Arriving in 1882, Nahigian originally worked for the Washburn and Moen Manufacturing Company but soon became an independent businessman. Nahigian was known as "Mr. Welcoming Committee" for Armenian immigrants to the city, helping them to

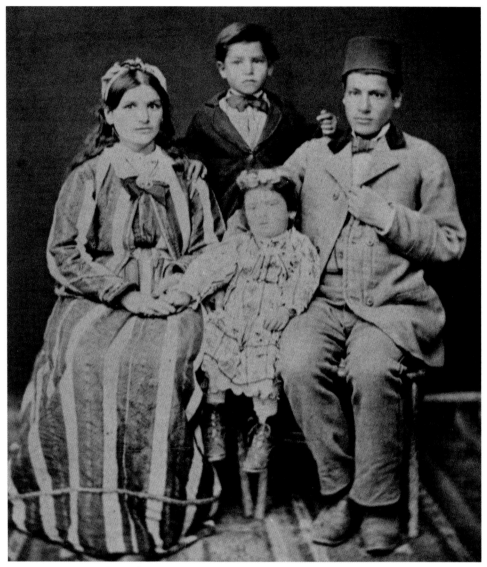

A young Mgurdich (in fez on right) with siblings (circa 1885), photographer unknown

find housing and employment while he grew prosperous in the fields of insurance and banking.[8]

Mgurdich Hovhanessian was intrigued by the news from the United States and decided to make the passage across the Atlantic. In 1885, Mgurdich left school and traveled to the United States. He arrived in New York City in August and soon joined his brother-in-law in Worcester. [9]

The record is unclear as to Mgurdich's age when he arrived in the United States. The young Armenian was timeless in many ways—the various official and unofficial documents, including census records, the marriage register, his naturalization petition, letters, and newspapers, list his potential date of birth as 1867, 1868, 1870, 1871, 1872, 1874, 1875, or 1877. In the rural areas of the Ottoman Empire, records were not well kept, and families would sometimes track their child's birth to "when the cow had a calf." Part of the puzzle might also be due to Mgurdich's uncertainty of his birthdate or a humorous desire to make people think he was getting younger rather than older. [10]

Filled with dreams of a new life, Mgurdich sought to immerse himself in his unfamiliar surroundings. Like many immigrants, he chose a more "Americanized" designation and took the name John Garabedian (son of Charles). Later he shortened his surname to Garoian and then again to Garo, becoming finally John Higue Garo, commonly known as Jack.[11]

M. S. T. Nahigian was able to find a job for John Garo as a general laborer at the Washburn mill making barbed wire. But life as a Worcester mill worker did not provide much comfort for a young immigrant. A contemporary account of the Washburn work floor describes the conditions Garo experienced: "The heat is unbearable. A worker can stand near his oven only a couple of minutes. The place is dense with acrid smoke. I left suffocating after a few minutes." It was no wonder that Garo found the mill to be "the place alien to his artistic nature, and left his job the very day he found it." He sought to find better employment elsewhere in Worcester, but it was a difficult time for a person of limited skills to find anything better in the United States.[12]

After "a week's aimless wandering," John Garo entered the Worcester YMCA, where he found space to rest and reconsider his next move. To keep himself busy, he began making sketches, and his work attracted the attention of another patron sitting nearby. Once the man

discovered that Garo was Armenian, he decided to help him. The drawings were shown to the YMCA secretary, who was impressed enough to contact another person, and soon the young immigrant was hired as an office boy at the George C. Whitney Art Publisher and Importer Company.[13]

The Whitney Company was at that time the world's largest greeting card company, with sales offices in Boston, New York, and Chicago. Garo worked in the office "learning English and the right way of living from the girls of fine families," who surrounded him. It was not long before he proved himself and was promoted to illustrate Valentine's Day cards.[14]

But his work as an artist was providing only "a slender living," so Garo, needing to add to his income, began looking for a part-time position. Establishing a friendship with an Armenian photographer in Worcester, Garo was offered work as his assistant in 1887. His goal in joining a photography studio at this time was more to "earn a livelihood" than to become a professional lensman.[15]

And yet, Garo was not satisfied with the opportunities available in Worcester, and the small city began to feel confining to him. He yearned to work on his art and to be with individuals who could guide his intellectual growth. He also felt immured in the ethnic community that was "Little Kharpert" and defined by his identity as an Armenian in his adopted nation. Mr. Whitney, aware of Garo's artistic talent, encouraged him to explore Boston, a city nearly six times the size of Worcester and a greater center for culture and learning.[16]

Unlike his family and fellow immigrants, Garo was restless and unwilling to settle. In many ways, the decision to leave Worcester illustrated a higher search for identity. One acquaintance noted, "I think the way he lived his life he was in the moment. And you know, his art, and assimilating into American life and getting known over here, and he didn't really have time for the old country And Garo

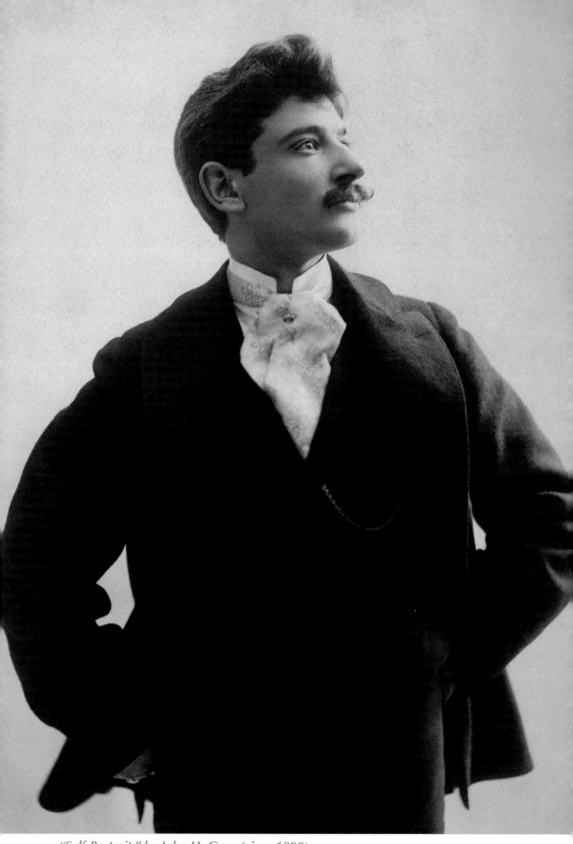

"Self-Portrait," by John H. Garo (circa 1890)

went off into the big world. He just got out of there Garo had no fear of walking away from the tribe, and you know, mingling with Americans, and Irish, and everybody else."

Pulling up his newly planted stakes, Garo quit his position with Whitney as well as his photography job, left his Lancaster Street apartment, and moved to the commonwealth's capital in 1889. There, in Boston, John H. Garo would undertake his quest for renown.[17]

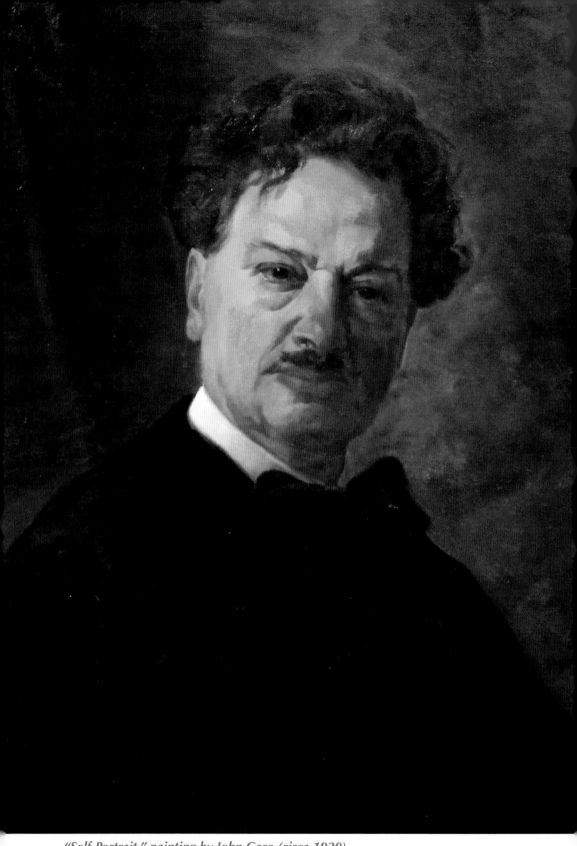

"Self-Portrait," painting by John Garo (circa 1920)

Chapter 2

DEVELOPING

In 1889 Garo arrived in Boston, a city with a greater center of cultural gravity, which he hoped would be more conducive to his art. During the next decade he moved frequently within Boston, neighboring Revere, and West Medford, and had no fewer than ten addresses in as many years. Eventually he settled in a flat on Paul Gore Street in the Jamaica Plain neighborhood, about four miles from downtown.[18]

In 1890, Garo found a position as an artist with the Beckford Photo Studio at 43 Winter Street near Boston Common. Here Garo joined proprietor D. C. Beckford and three other assistants working to colorize photographic portraits using a variety of mediums including crayon, pastel, watercolor, India ink, and oil paint.[19]

After work, Garo spent his time honing his skills as a painter. During these first few years in Boston the young artist attended the Massachusetts Normal Art School, taking courses in painting and drawing under the tutelage of Ernest Lee Major. His artwork at this time was primarily landscapes, first watercolors and then oils. The scenes he chose to represent varied, from the fading fury of a burning ship to a

Early example of Garo's watercolors and oil paintings

rocky New England brook to pastoral views of snowy countryside and old farmhouses. The oil paintings were often heavily textured, while the watercolors exhibited a lighter, almost mystical quality.[20]

Garo also sketched with pencil and created monotypes, often of the human form—a partially hidden nude profile or a portrait of an old man searching for life's answers. The only known portrait painting by Garo is one of his own likeness, and it exposed his limited abilities in the genre. The self-portrait shown here, while capturing his personality in some ways, gives the impression of a caricature. However, his still-life oils demonstrate a fluency in the conventional style of the time, just prior to the rise of art nouveau and expressionism.[21]

In 1892, Garo had the opportunity to exhibit a watercolor, titled A *Flowery Slope*, in the spring exhibition of paintings at the Boston Art Club. His work attracted no real recognition, but its inclusion in the exhibit was important in exposing Garo to a new audience. The art club, one of the city's elite institutions, was a place to showcase his talents. And Garo undoubtedly realized that the patrons of the

art club, and other members of the Boston establishment, would be crucial to his success as an artist.[22]

To this end, Garo began attending parties around the city and meeting people from different segments of Yankee society. At one such function, a young woman named Alice Mary Sanford apparently caught his eye. Alice, who was visiting friends in Boston, was described as a "handsome blonde," tall and "of aristocratic and graceful appearance." She was of English stock, by way of Nova Scotia; while not a Brahmin "insider," she was accepted into the social circles of the clientèle Garo was seeking.[23]

It was not long before Garo and Alice were engaged, and a grand wedding was planned for the fall of 1895. But that Au-

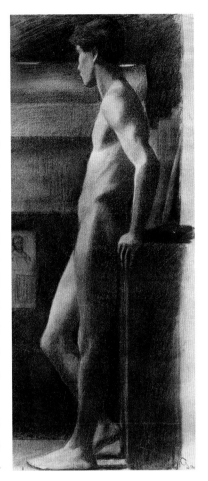

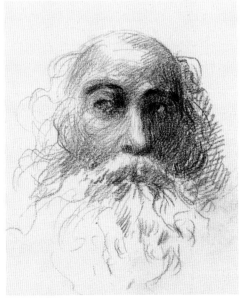

Garo's early sketches (dates unknown)

gust, when Garo was visiting his sister's family in Worcester, word came that Alice Sanford also happened to be in the city. And coincidentally, another visitor at the Nahigian house was the newly ordained Armenian Congregationalist minister, Reverend Kaios Kemalian. Ever the leader, Garo's brother-in-law, M. S. T. Nahigian, declared, "Here we have water, and a pastor, and the bride and groom are here: what is the matter with getting married now?"[24]

And so a wedding was hastily arranged at the Nahigians' Uxbridge Street house, with Garo's niece, Bessie Nahigian, as bridesmaid and his brother, Martin Garo, as best man. Opening with strains of Mendelssohn, played by one of the Nahigian boys, the ceremony was conducted partly in English and partly in Armenian. After the vows, the party enjoyed an "elegant breakfast," followed by the newly married couple's departure for their nuptial vacation at nearby Lake Quinsigamond.[25]

After their honeymoon, the couple returned to Boston, eventually moving into a new house at 83 Perkins Street in Jamaica Plain. The house was just a few minutes' walk to Jamaica Pond and Ward's Pond—part of Frederick Law Olmsted's "Emerald Necklace"—and Garo relished taking his paints and canvas out to capture the scenes of natural beauty. He devoted himself further to his goal of artistic creativity, venturing out on his own as a professional painter. But even in a place like the Athens of America, the world of art was a competitive one and a difficult profession in which to succeed, especially if one had a wife to support as well.[26]

Tragic news arrived in the fall of the same year with the massacres of the Armenians of Kharpert and the surrounding areas by members of the Turkish and Kurdish populations. The attacks, occurring in November of 1895, were leveled against the Armenian citizens and institutions, including Garo's alma mater, Euphrates College, which was set on fire and partially destroyed. An American living in the area at the time documented the impact on Garo's birthplace, Hoghe: "Ar-

menian church, Protestant chapel and parsonage burned. Those killed had kneeled to receive circumcision. Fifty-five women and children taken to harems and Turkish villages. Women and girls outraged."[27]

After several days of terror, much of Kharpert was "plundered and burned," and approximately 200,000 people were killed in the massacre of the city and neighboring countryside. Among the victims were Garo's entire family, including his parents.[28]

It was a horrific severing of connections to his homeland, but Garo seemed not to dwell on the loss of his relatives in Kharpert. Although other family members in Massachusetts "were really anti-Turk" and "still living the genocide," Garo "lived his life in the moment." While the young artist was not unsympathetic to the plight of Armenians back in the empire, his family thought he "didn't really have time for the old country." Instead of being consumed by sorrow, he assiduously labored at his artwork.[29]

But perseverance did not result in success for Garo, even in Boston. Art appreciation is highly subjective, and most people probably thought of Garo's paintings as good, not great. He lacked an audience for his work, and making a living as an artist proved to be a challenge. Garo stayed the course for several years and gave it his best effort before deciding to close his business up for good.[30]

Through his time working for Beckford, Garo realized that photography was a steadier commercial vocation than painting and decided to pursue this art while still painting on the side. Intending to learn the language of the lens, Garo sought out the help of more-established cameramen around town. In 1896, he began an apprenticeship with James E. Purdy of 146 Tremont Street, posing for his portrait there as well. Through Purdy he found another mentor in Elmer Chickering, a fairly prosperous photographer whose office at 21 West Street was wisely advertised in the days before elevators as only two flights up. In 1897, Chickering agreed to bring Garo in as an understudy to begin his work

Portrait of John Garo, by Elmer Chickering (circa 1890)

as a portraitist. Chickering's studio was a busy place, where some of the city's most prestigious citizens and "leading families" came through the doors.[31]

Taking his role as a photographer seriously, Garo began exploring with the camera, attempting to find different ways of using the current and ever-shifting tools of the trade. Photo technology at this time was changing almost annually, and "by 1900 . . . countless photographic techniques had come and gone." Garo was always testing new ground, utilizing ideas borrowed from diverse schools of inspiration in order to create novel compositions. But with his photographic work, he was described as "never wholly satisfied" and "constantly experimenting."[32]

In his early photography, Garo was pushing toward a sense of artistry he saw represented in the works of Rembrandt, Velázquez, and other classical painters, employing chiaroscuro in his photographs just as these artists had in their paintings. Some of his earliest photographs are of characters from Victor Hugo's *Les Misérables*, such as Father Fauvent and Monsieur Thénardier, photographs in which shadows gather in the deep wrinkled features of the subject. They are stark images that convey a sense of the dignity of the common man and the photographer's ability to highlight this aspect by contrasts of light and dark within the portrait.[33]

Analyzing Garo's photography, P. K. Thomajan wrote,

> To Garo, light created space and roundness, and he dis-
> tributed his light planes scientifically by emphasizing
> them on the face and "using less light" on the body. In
> his standing figures, both head and body are seen under
> common light, but the light values in the figure grow
> more and more subdued the farther they recede from
> the predominating light. Sometimes his strongest light
> accents shimmer like pearls set in a deep rich tone to
> which the rest of the composition is subordinate. Re-
> serve and fidelity go hand and hand in his work. His
> style is composed solely in two principal tones, a light
> and a dark, which his technique mutes and almost mag-
> ically transmutes.[34]

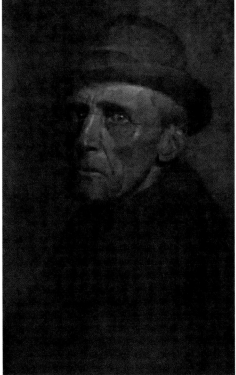

"Father Fauvent" (1902) and "Monsieur Thénardier" (1901) by John Garo

Garo worked in the pictorial style with the intention of conveying artistic ideals through the medium of the lens. Pictorialism sought to replicate and extend the values embodied in impressionism, and Garo's work often relied on deep layers of shadowing and an emphasis on a soft focus. Garo employed his equipment toward new achievements. He was one of the first Americans to work in the cliché-verre or verreograph method, whereby a print was created from a sketch done on a photographic glass plate matched up with light-sensitive paper. It was Garo's restless sense of inspiration and innovation that pushed him to combine creative forms, and by doing so he became a fuser of photography and art.[35]

Although Garo met many members of Boston's elite while taking their photos at Chickering's, the barriers to joining this society were high. When he tried to become a member of an exclusive men's club in Boston, he was turned down because he was an Armenian without the requisite blue blood. Not only his ancestry worked against him, but his art as well; photography was a relatively new art form, and many in the arts community, especially in traditional Boston, looked askance at the field. Many painters "inveighed heavily against" camera work as an art form, and "photography all along had to encounter malignant opposition" in its attempt to be fully recognized. Influential institutions, such as the National Academy of Design, were prohibiting photographers to join, and when Garo applied for membership at the prestigious Boston Art Club, "the committee on admissions recognized his distinguished ability; but as the club did not regard photography as one of the fine arts," he was denied entrance.[36]

Garo attempted to gain entry to the cultural establishment not only to succeed professionally but also to feel accepted as an American citizen. Unfortunately, he was blocked at every turn. And to add to his disappointment, Garo still lacked the title he desired most—to be called an artist. But the prejudices he discovered only made him work more diligently.

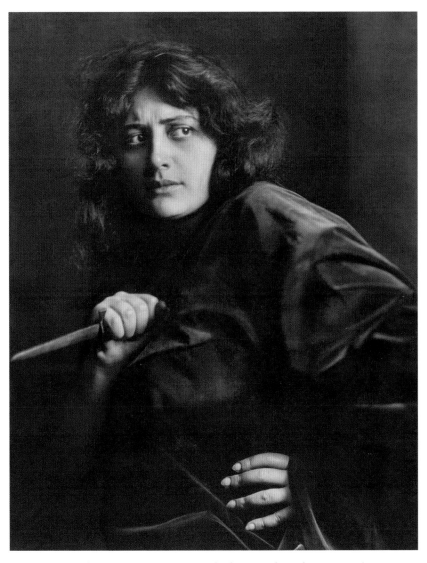

Malvina Longfellow (in character with dagger), by John Garo (circa 1905)

As traditional forces guarded the gates, Garo joined with other like-minded individuals who were part of the burgeoning photographic scene in Boston. He became a member of the Boston Camera Club and a founding member of the Lens and Brush Club upon its establishment in October of 1900. At the first formal meeting, Garo was elected secretary-treasurer and worked to make the new organization a success. The club was a dynamic group consisting of artists and photographers who met twice a month to discuss one another's work.

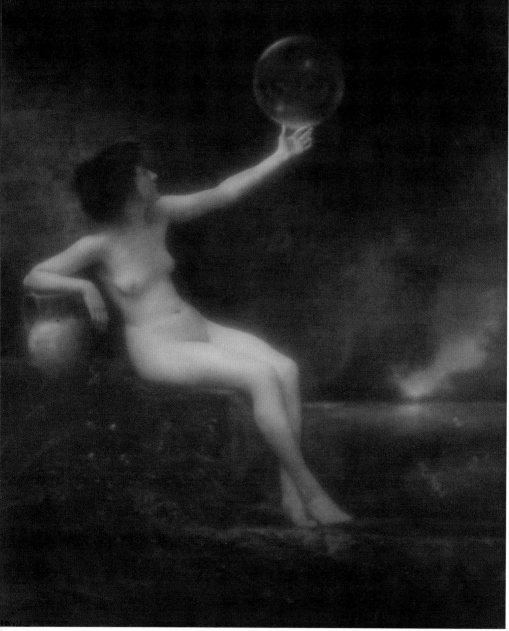

"Bubble," by John Garo (1914)

They also offered courses in photography and in drawing—purportedly the first to use nude models in Boston.[37]

Through these organizations, Garo found a community of Bostonians who shared in his desire to identify photography as a valid art form. They fought for acceptance in the face of indifference or outright rejection from the cultural elite. And they recognized one

another in both established organizations as well as more informal assemblages, as described by a visitor to town:

> Clouds of tobacco smoke, the clinking of glasses, an obliging waiter and the babble of voices—it is Saturday evening in the Cafe Thorndike at Boston. Yonder is the corner where the leading photographers of the city congregate—a happy little family! There is Garo, the jolly Armenian, whispering impossible photographic things

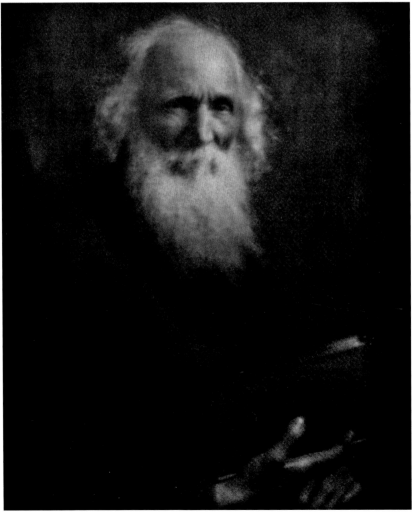

"Art Study from Model," by John Garo (circa 1900)

into his neighbor's ears; Evanoff, with his peculiar
laugh and high "we are it" art talk; little Oppenheim,
whom everybody likes; and Henry Havelock Pierce, the
man of indomitable courage and champion of "pictorial
expressions.". . . And there they sit for hours until the
night turns gray with the longing for dawn, never tiring
of discussing pictorial problems and art in photography.
They criticise each other's work frankly, but without
taking offence at any remark that might be made. They
speak of their latest work, compare it with that of oth-
ers, instruct and help each other photographically and
artistically as much as they can. Nobody is better than
the rest, no matter how lavish or primitive an establish-
ment a man may have; they are all on equal footing and
equally welcome to the crowd.[38]

Garo also joined the Photographers' Association of New England, and through that organization he exhibited one of his photos, which was selected for display out of hundreds of other images at that time. Garo's creative talent came to be appreciated in numerous circles; and, beginning in 1901, his images were featured in the major journals of the day such as *Wilson's Photographic Magazine*; the *Camera*; and the *Photographic Times*. In another sign of growing acceptance, Boston's Museum of Fine Arts displayed one of his works in a show that same year.[39]

As Garo's reputation grew, he engaged the support of a leading architect to design and build "an imposing studio," and in March 1902 he opened his doors for business. Garo advertised his new enterprise in the *Boston City Directory* as offering "Artistic Portraiture" and stamped a unique Persian-inspired emblem of his name into the announcement. The studio occupied the second, third, and top floors

of a brand-new structure erected near Copley Square and designated Boylston Chambers.[40]

The Boylston Chambers building, located at 739 Boylston Street, was of a grand scale. Designed by the architect Clinton J. Warren, the six-story building was known for its Chicago-style windows and an elaborately decorative, cream-enameled terracotta entrance. Inside, visitors discovered a large skylight, which illuminated a central marble staircase, patterned marble floors, and mahogany woodwork.[41]

Aside from its engaging architecture, Boylston Chambers was

June 1914 edition of Wilson's Photographic Magazine *devoted to Garo's work*

also a hub of cultural activity. Boston's Copley Square neighborhood was an emerging center for education, the arts, and fine living, and the building on Boylston Street reflected this development. Garo's neighbors in the building originally included Simmons College, the Museum of Fine Arts' School of Design, and the Frye Private School. Offices in the building included those of architects, artists, interior designers, and photographers. It was an environment in which Garo thrived.[42]

As an axis for cultural activity in Boston, Boylston Street was also the center of photography in the city.

Garo's signature studio emblem (circa 1902)

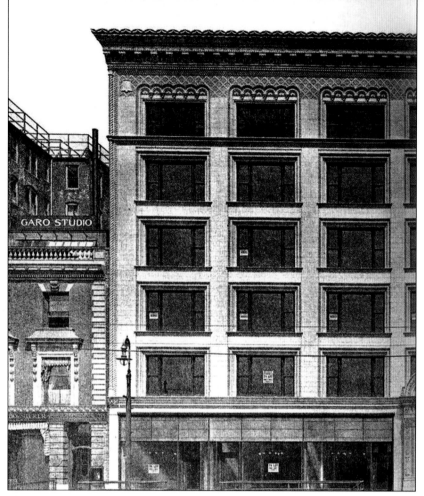

The Boylston Chambers Building (1903)

Approximately thirty professional photographers lined the one-and-a-half-mile stretch from Washington Street to Massachusetts Avenue, including Garo, Baldwin Coolidge, Henry Havelock Pierce, Mary L. Patten, Charles W. Hearn, Helen Messinger Murdoch, and Bachrach Studios. The entrepreneurial and artistic vibrancy of the area led it to become known as Photographers' Row.[43]

Garo's atelier in Boylston Chambers had a high ceiling that reached about sixteen feet above the floor. The architect had designed an immense skylight that occupied most of the ceiling in order to obtain the northern light exposure Garo needed for his work. Also installed were a system of roller shades that could be manipulated to allow light and shadows to fall into place wherever the artist required. Garo was

"Portrait," Photo-Era: The American Journal of Photography,
March 1906

"Simplicity," by John Garo (1915)

"immensely clever" in working the shades and "worked for so many years under this skylight that he seemed to use it instinctively, without conscious thought."[44]

Over time, Garo's studio was richly decorated and meticulously

designed to make customers feel at ease. In the reception rooms, clients would relax on a Louis XIV divan and take notice of the decorative Japanese screen or the numerous kilims imported from the Old Country. On the walls hung several of Garo's paintings, while the floors were covered with Persian rugs and a full-bodied tiger pelt. In one corner stood a giant brick fireplace with an iron cauldron; a whale oil lamp; and a mantelpiece showcasing a dusty musket and an assortment of antique jugs, plates, bottles, and vases. And overlooking it all

Unknown subject by John Garo (circa 1914)

was a large moose head, whose antlers provided useful stewardship of Garo's hat collection.[45]

Although Garo would on occasion take a portrait at a special client's home, he strongly encouraged his clientèle to "make appointments for studio sittings whenever possible." An observer noted that the studio "had something of the atmosphere of a 'quiet room' in an exclusive club, and the soft cushioning of the rugs did not detract from this feeling of hushed beauty. It is hard to say whether all this would have caused ordinary visitors to relax emotionally, or simply to be impressed. But . . . it was not designed to impress visitors, least

"Twilight," by John Garo (1914)

of all to attract them; it was designed to compose them."[46]

Garo's ability to put his subject in the right mood was legendary. It was noted that one of his "great gifts was his ability to fascinate, to enchant the subject to such an extent that the latter was really unaware of the act of photographing." While he was readying his equipment Garo would burst into song—often a classical Italian opera—in a deep baritone voice and make the clients laugh. He would discuss ideas or "some abstract topic,"

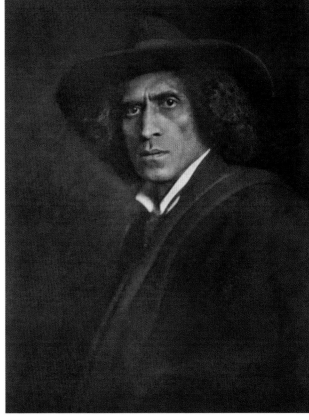

"Cavalier," by John Garo (1915)

or ask the client to focus on one of the many decorative pieces in the studio. Then, when the perfect photo was in his view, he would raise a finger and in a gentle manner ask the client to "hold!" while he clicked the shutter.[47]

Garo's facility with people grew as he sought to make a name for himself and become an integral part of the community. He learned French to impress his clients and make them feel as if they were in a Parisian salon. He dressed with a flair for the dramatic: a long and fluid silk polka-dot bow tie, a pince-nez, and the black smock of an old master . . . all topped with "his mop of wavy hair." And in order to keep himself fit, Garo practiced boxing, working to "cultivate muscle daily in a Back Bay gym."[48]

He hired a Yankee woman, Miss Edith Ames, to run the business end of the operation. Ames was from a well-known Boston family and acted as a proper point of reception for his blue-blood customers so

that "they saw one of their own sitting there." Garo, with his artist's mind, needed someone who was organized and could handle the details of appointments and paying the bills, and Miss Ames provided a perfect match, holding court and helping Garo to run "a tight shift." The building's elevator operator, who delivered clients to the top floor studio, was another indispensable assistant, to whom Garo generously gave two fine cigars each day in return.[49]

Business increased as word of Garo's unique style spread, and he began calling his creations "Garographs." Still following his innovative artistic impulses, Garo continued to push the traditional boundaries of photography and portraiture. When he exhibited one of his photos, *Portrait of Miss Chase*, at the Boston Lens and Brush Club, his fellow photographers were highly impressed. Garo's use of chiaroscuro brought accolades from viewers, while artist Wilbur Dean Hamilton declared it "the finest photograph he had ever seen."[50]

In analyzing Garo's photographic style, reviewers saw something new in his work. While not quite sure how to categorize him, Boston news correspondent A. J. Philpott had high words of praise for Garo:

> *The difference between John H. Garo and the average photographer is that Garo is an artist. This may seem both enigmatic and paradoxical. It is neither. John H. Garo uses photography to accomplish an artistic purpose, and he uses it as an artist uses brushes and paints, or a sculptor clay and marble. It is one of his mediums of artistic expression, and not the only one by any means. . . .*
>
> *Garo has proved in this generation what Napoleon Sarony proved fairly well thirty years ago—that photography is not only a science, but is also very much a fine art if it is thoroughly understood by an artist; and that*

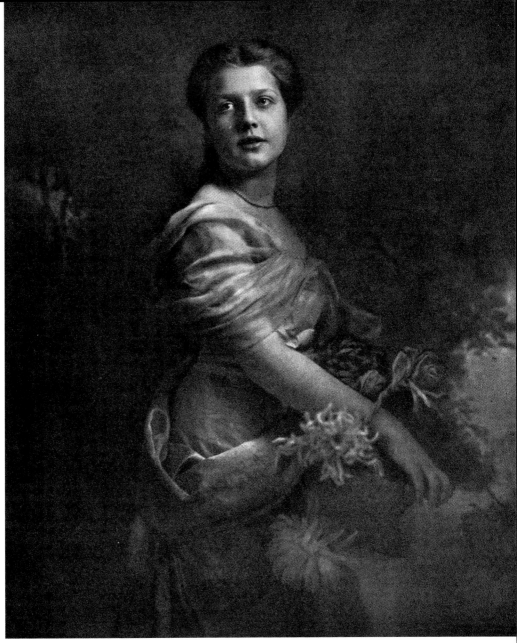

"The Flower Girl," by John Garo

it is a flexible medium, with a wider range of artistic possibilities than was dreamed of.

John H. Garo looks on the ground glass of his camera with an artist's eye. But that is not all. He sees beyond the glass all the stages that the negative has to pass though until the print is finished and mounted. He

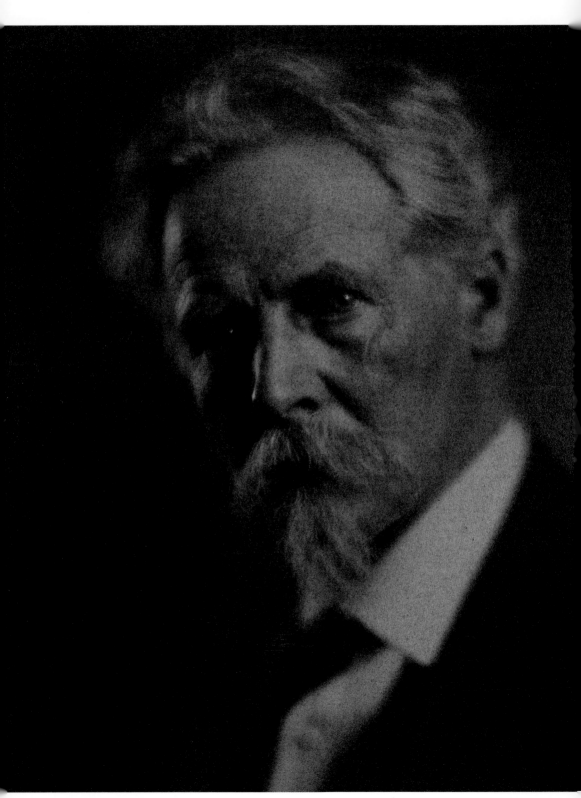

Portrait of unidentified man, by John Garo

understands the artistic limitations and possibilities of every one of those stages. . . .

Garo is as much of an influence in the world of artistic photography as great painters and sculptors are in their fields. He is the hope and despair of many photographers.[51]

When art critic Sadakichi Hartmann came to visit Garo in his studio, he came away with an indelible impression:

When I first met J. H. Garo I hardly trusted my eyes. Surely that man can be no adherent of old pictorial formulae and a T-square art—no ordinary photographer! Why, with his hat tipped over his eyebrows, and a hand shaped like that of a painter's, caressing a mustache that is defiantly twisted up—he has the air of some Bobadil of Tripolis—of a pirate of the Algerian coast. Nevertheless, he is a photographer, but one who can draw and who does not hesitate to make use of these qualities and paint like an artist in his portraiture. . . . There is a place for the clear, sharp, over-retouched portrait. There are times when the old ways are aptest and best. But Garo himself wanders on new roads.[52]

It was on these new roads that Garo sought a destination worthy of his dreams.

This portrait of a man with a white beard shows Garo's selective use of depth of field. It would seem as if everything were out of focus, but in fact, if you enlarge the man's eye closest to the camera, it is the one thing that is sharp, and that is where the attention is drawn. It is not an accident of poor craftsmanship but a selective tool of artistic interpretation.

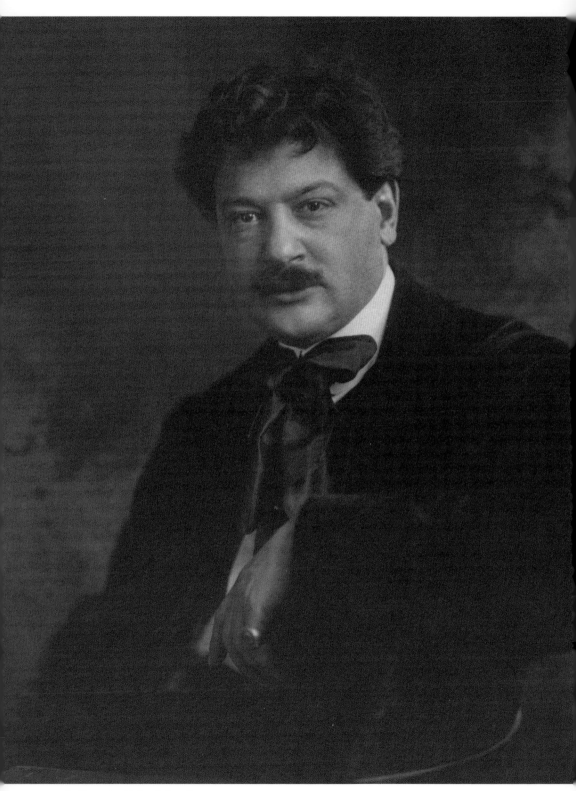

Self-portrait, by John Garo

Chapter 3
FLASH!

With a new studio and a growing body of patrons, Garo began to re-
fine his work and set himself apart from competitors. He targeted an
exclusive corner of the Boston market and profited from his expertise
behind the viewfinder. He was also bold enough to oblige customers
to come to his studio, where he could take advantage of the ample
natural light.[53]

Garo's appeal to potential clients was dramatic and literary in tone:

> Dear Mr. Jones:
>
> The last few years have changed the life, the feelings,
> the thoughts—of every one of us. Some have lost, some
> have gained much, though hardly an individual but has
> felt vital reactions from the events of recent years. His-
> tory will record these great events, while fiction will tell
> the lighter and dramatic phases of the conflict, but from
> this trying period what record peculiar to yourself have
> you made to satisfy the natural interest and affection
> which your friends and relatives feel?[54]

By 1906, Garo's work had increased such that he opened up a second studio at 8 Congress Street in Boston's financial district to photograph "the sterner sex." And in order to capture clientèle during the summer, Garo opened yet another location in Beverly Farms, Massachusetts—a seaside community for Boston's patrician class. An energetic visionary, Garo was at the forefront of the growing change in fashion among the elite from oil portraits to photographic portraits. And although Garo was charging up to one hundred dollars for a sitting in 1906, this high price seemed to increase his business rather than discourage it.[55]

In many ways, Garo denied any differences between photography and art. He was constantly seeking to change how people viewed images on paper and to bring parity for the camera as an instrument of creativity. In 1906, he volunteered on a committee that worked with Congress in order to update the copyright laws affecting photography. The government had previously mandated that the copyright symbol and other relevant information appear in a corner of the photograph, thereby ruining the potential artistry of the image. Garo and the other committee members' work helped end this restriction through the passage of the Copyright Act of 1909, which allowed the copyright mark to be placed on the margin or back of the photograph and which also recognized photographs as "works of art."[56]

His efforts to erase the well-defined boundaries between photography and painting led his studio to become a venue for the showcasing of top photographers and painters both. In May of 1905, Garo hosted an exhibit of Boston's most eminent artists, including John Singer Sargent, Edmund Charles Tarbell, Frank Weston Benson, Ernest Ludvig Ipsen, William McGregor Paxton, and Garo's own former teacher Ernest Lee Major.[57]

Sargent's contribution to the exhibit was a fine charcoal sketch of Boston rabbi Charles Fleischer, a leader in Reform Judaism who

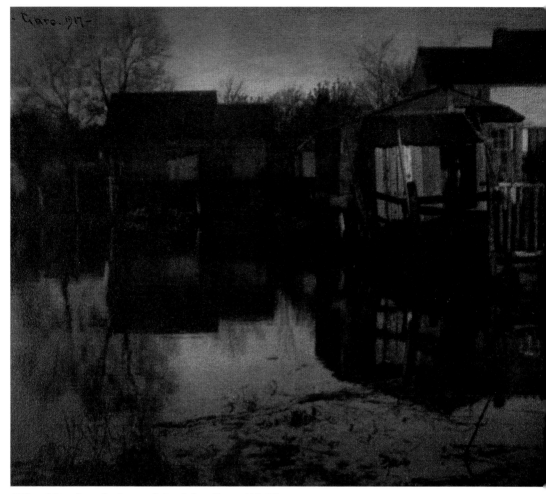
"Flood," color photograph by John Garo (1917)

was known as the "Beau Brummel of the Back Bay." Much like Garo's work, the sketch's shading of variant grades demonstrates Sargent's ability to simulate what the eye sees in reality. The show was well received, even with Garo's ingenious and unconventional display of paintings, sketches, and photographs side by side.[58]

Garo was a natural mentor and often agreed to open his gallery to artists who wanted to exhibit there. In 1906, before he had undertaken his great study of Native Americans, Edward Curtis was looking for a place in Boston to show his modest collection of photographs. Garo welcomed him into the Boylston Chambers studio and invited to the

opening "successful men" and "elegant women interested in photography, the sciences and history of western life." Leaving Boston, Curtis went on to New York and acquired financing from J. P. Morgan that led him to become the great documentary photographer of Native American life.[59]

But the salon on Boylston Street was much more than just a portrait studio or an exhibition gallery for photography and art. Garo turned his workplace into a reputable concourse for cultural and social activities. He welcomed guests from diverse fields to his venue: Dr. Charles Fleischer came to give a presentation on the difficulties African-Americans were facing in the United States, and his lecture was followed by a performance by the tenor Roland Hayes, a noted African-American classic concert singer. Garo openly invited African-Americans into his studio, which illustrated his open-mindedness at a time when that was not readily acceptable. Henry F. Gilbert appeared with soprano Sarah Drake at Garo's studio, where they premiered Gilbert's composition *Orlamonde*. Opera previews attended by the mayor of Boston, an afternoon of music presented by the Prelude Club or the Chromatic Club, lectures by the American Drama Soci-

Wollensak Advertisement from Photographic Review *(January 1920)*

ety, the annual meeting of the American Music Society—they were all part of the Garo Studio's offerings.[60]

Garo's sociability extended everywhere. He often met friends for dinner across the street at the prestigious Lenox Hotel, which had opened in 1900 and was the tallest building in Boston at the time. The Lenox was the scene of many memorable gatherings organized or attended by Garo, including a fete for horseman and entertainer Joseph Collins, who rode into the hotel's second-floor dining room on his pony "Darkey." Garo was such a regular at the hotel that he became a minor celebrity. The Lenox menu listed the "Garo Sandwich," while another dish with sautéed chicken and spaghetti was known as "à la Garo." He even lent his name to advertisements encouraging visiting photographers to stay at the Lenox whenever they were in Boston.[61]

Garo's name became a valuable commodity employed to sell photography-related products. Garo endorsed products for companies such as Ansco, Haloid, Willis and Clements (maker of photographic print paper), the Spencer Lens Company, Goerz American Optical Company, Robey-French Company (maker of photographic backgrounds), and Wollensak Optical Company. He also agreed to judge photography shows, including the International Photographic Arts and Crafts exhibition in New York, *American Photography*'s annual competition, the Kodak Advertising Competition, and even the amateur camera club's gathering at the Milton, Massachusetts, public library.[62]

When he was not participating in competitions as a judge, Garo was receiving prizes for his work, including the Pan-American Exposition Medal, the Gold Medal Grand Portrait Prize and Salon Honors from the Photographers' Association of New England, the Aristo Trophy, the Jamestown Tercentennial Exposition Award, and the C. P. Goerz Silver Cup Competition. Having won the Silver Cup three times, he was granted permanent possession of the silver trophy. In

October 1904, Garo was invited to include his work in the International Photographic Exhibition in Berlin. Kaiser Wilhelm II attended the show, and upon seeing Garo's images declared, "Never in my whole life have I seen such marvelous and beautiful photographs." In 1909 at the International Exhibition of Photography in Dresden, Garo was awarded the silver medal.[63]

But soon after the Dresden award, Garo received a harsh appraisal in *Camera Work,* the publication produced by Alfred Stieglitz, the leader of the photo-secession movement. The avant-garde Stieglitz was perhaps the most famous photographer of his day, but he was also known for his complex personality and his occasional displays of hostility, which earned him an unfortunate reputation as "the dictator of American photography." *Camera Work* criticized Garo's exhibits at the Dresden Exposition by declaring his photography was "essentially a trick," imitating painted portraits and "being more or less characteristic of the contrivances for tickling the popular taste." Garo's work, according to the journal, was in the business of creating "bastard prints" and accelerating the tendency "to lower the dignity of the craft."[64]

Undeterred by the criticism *Camera Work* levied against him, Garo sought out Stieglitz to bring him and his group into communication with many of the "regular" commercial photographers who would benefit from exposure to the skilled secessionists. Garo personally wrote to Stieglitz, inviting him to be the guest of honor at an upcoming annual photography convention in New England:

> *I am strongly convinced that the time has arrived when you can consistently use your power and influence in helping to still further bring the professional photographers of the country to a realization of the truths for which you have been fighting for so long.*

The wonderful success of the Buffalo exhibition has opened the eyes of professional men everywhere and I am sufficiently in touch with the field to know that they feel that your battle is won. They have long since acknowledged their debts to you and your fellow-workers and if there is a way to bring the members of the craft in closer touch with you I would like to be the means to the end.[65]

Stieglitz responded the following month from Montreux, Switzerland:

Dear Mr. Garo:

For some reason or other your very kind letter dated July 5 only reached me yesterday evening. I hasten to acknowledge its receipt for fear that you might misconstrue my innocent silence as non-appreciation of your more than kind words. Were I in America I would gladly come

It was faith which won the battle for us all. Photography is a much more wonderful medium of expression than its staunchest adherents realize today. As I travel and study what art has accomplished in the various countries and what nature really means and is, photography's possibilities assume gigantic proportions. It is to the men who understand nature and love it, and who love photography, that the future will bring about revelations little dreamed of today.[66]

Garo became a subscriber to *Camera Work* and wrote Stieglitz to extend his "sincere appreciation" for the artistry within. Stieglitz

replied, "Naturally I would like to see your work and that of your colleagues and there are many other things in Boston which I not only would like to see but ought to see. So don't be surprised if some day I look you up when you least expect it."[67]

In 1910, Garo became involved with the Photographers' Association of New England. By this time, however, the organization was nearly defunct. Recent conventions were considered a "dismal failure," and attendance was low, often no more than fifty, at the annual meetings. A critic observed, "The general apathy displayed would indicate a very speedy end of this once powerful and flourishing association."[68]

The New England association's pioneering spirit had dropped off over the years, and people criticized the organization's leadership as being out of touch. Some of the members believed that Garo could provide the energy and respectability needed to improve the organization, and soon there were calls for him to take over its leadership. During a meeting in July of 1910, Garo declined the group's nomination to head up the organization, and another candidate was pro-

Yearbook of the Photographers' Association of New England,
Bridgeport Convention (1911)

posed. But his supporters were undeterred, insisting until Garo finally relented and accepted their nomination. At the last moment the official nominee stepped down, and Garo "was elected by acclamation" as the new president.[69]

Under Garo's leadership, the association pursued the establishment of a national academy for photography and a "Home for Incapacitated Photographers" as a means of social security for aged members of the field. His tenure as president was also known for its "radical departures from accepted practice," including efforts to relocate the association's annual convention from Boston to another city—Bridgeport, Connecticut—and open up its displays to photographers outside the membership. Garo improved the reputation of the association, eliminating its former stuffiness and pedantic tendencies (the previous president's speech for the annual president's address went for twelve pages, double columned, single spaced). Garo added zest to the mix. New guidelines announced, "Every picture sent to the convention will be hung if the man who sends it says that the collection represents the best photographic work he can do." And due to Garo's democratic initiatives, the exhibition grew from a single location to the Crystal Palace on Steeplechase Island to accommodate the hundreds of additional photos on display.[70]

Garo incorporated his Persian emblem into the design for the convention's membership buttons. Over seven hundred were recorded as having been issued, breaking every previous attendance record. Garo declared the convention hall a "Temple of Art," and the annual meeting was a resounding success. Journalists noted that the event would go "down in history as the unconventional convention," and President Garo was given full credit for raising the association out of its doldrums and making its "dry bones live."[71]

Outside of the New England association, Garo also became acquainted with local photographers who visited his studio to learn the

new techniques of the trade. By the summer of 1911, Garo had attracted a small following of individuals who came often to Boylston Chambers to share their love of culture and art. Realizing that they were "meeting so frequently," they decided to form their own small club, which they called the Boston Photo-Clan, composed of a limited membership of twelve people. As for the clan's purpose, it "was understood from the start that there should be no dues, no formalities of any kind, but simply a working together as opportunity offered, with the object of building up the individuals' powers through association, common criticism, and exhibitions."[72]

Besides Garo, the members included Frank Roy Fraprie, Henry Eichheim, William H. Kunz, Dr. C. T. Warner, Dr. Harry B. Shuman, Clark King, H. Oliver Bodine, Dr. H. W. Smith, Dr. Malcolm Dean Miller, L. H. Trautman, and Maurice Wesley Parker. Several of the men went on to become well known in their fields, including Fraprie, the longtime editor of *American Photography*, the premier journal of its day, and Eichheim, who became "the first American composer to employ exotic instruments" from Asia in his musical works. Parker never excelled in a single field but should be remembered as an eclectic individual who took photographs, played both violin and golf, practiced taxidermy with the small game birds he shot, painted in watercolors and oils, taught drama and public speaking, wrote poetry, gave singing lessons, and was once the state billiard champion of Massachusetts.[73]

The group was described as a "band of brothers," with Garo as "the oldest and wisest acting as counselor and friend to all the rest." The photo-clan was a vigorous venue for ideas, and the members' enthusiasm led to their joking that a Dictaphone be installed at meetings to record the "apparent heat of the arguments," which "would make even the Croydon Camera Club sit up and take notice." Garo was ever helpful, pushing, critiquing, and encouraging the other members to

improve their photography while retaining their individual ideals in artistry. The photo-clan was soon widely known, and when the American Photographic Salon was held in May of 1912, the Boston group dominated the exhibition, with their work accounting for nearly one-sixth of the photography on display.[74]

Garo was constantly experimenting with the nascent medium, from using the latest photographic equipment to learning how to copy old daguerreotypes. His technical skills increased as he laboriously experimented with new methods. Patrons were placed in arrangements of subtle yet dramatic composition while the latest technological developments were employed for the maximum creative effect. Chemicals and paper morphed with light during darkroom experiments and were energized with Garo's unique blending of art and science. The final yield was described in specialized and meticulous terminology:

> *Study No. 2. Portrait by John Garo, Boston, Mass. This picture was made in an operating room 35 x 45 feet; style of light, top and side; size of light 20 x 22. The light was used wide open without diffusing curtains. Lens used, No. 10 Goerz, Series III; focal length, 22 inches; stop used, open diaphragm; exposure given, 2 seconds; plate used, Seeds 27, developed in pyro; printing process, Willis & Clements platinum paper.*[75]

Garo continued to press photography into uncharted realms. As early as January of 1908, he was advertising portraits produced in color using the "Lumière Autochrome" process. Here, Garo labored to create portraits obtained by the use of three separate color negatives and a sense of exposure timing "executed on intuition." The resulting work in this method was featured as the main illustration in *American Photography* and described with high praise: "For artistic merit, har-

mony of colors, and beauty of pose, it easily ranks with the best color photographs which have yet been produced."[76]

In Garo's compositions, sometimes the colors were radiant and bright, as in the *Italian Flower Girl,* while at other times the colors were muted and images "resembled a red chalk drawing" or shaded a light green, orange, or brown. The effect was completely original.[75]

In order to draw attention to the work, the Garo Studio produced a small brochure titled "A New Art," advertising "The Multichrome—A New Process in Color Photography." Garo explained the innovative nature of his process: "For many years I have been experimenting along these lines with some success, and at last I am assured have reached some permanent results that merit public attention. These results have been submitted to the attention of competent critics, who in turn have declared them to mark a distinct epoch in the process of color photography."[78]

Critics and fellow flashmen were inspired by Garo's new multichrome creations. A. J. Philpott, from the *Boston Globe,* wrote in a private letter:

> *My dear Garo:*
>
> *I have been very deeply impressed with the pictures I have seen in your exhibition—for these are real pictures. This is a kind of color photography which is certainly an invasion of the realms of fine painting. You get color effects in your photographs by means of this film-superimposition which I did not think was possible; and I doubt if exactly the same effects could be obtained in any other way. I can scarcely conceive of such rich color depths and subtle values by any single medium, such as water colors or oil colors, as you obtain in these portraits and landscapes—especially in the portraits.*

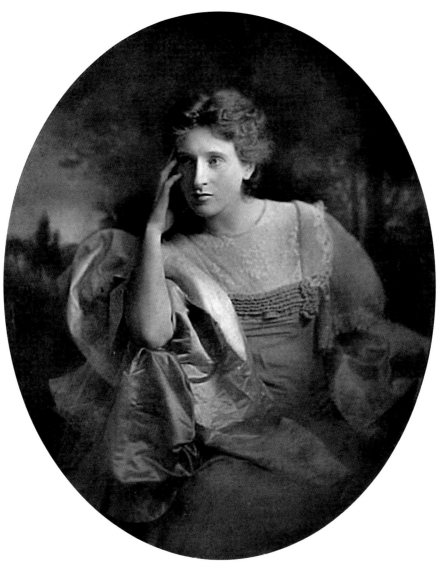

"Portrait Study Number 2," by John Garo (1909)

But I can also see that this process is not destined to become popular with the regular photographers, for the man who uses it, or even attempts to use it, must himself be first an artist, and he must not only have a clear understanding of the pigmentary relation of colors, but also of the spectroscopic relations of the colors. You will be very much alone in this field.

Artist Charles Chase Emerson followed with,

> *My Dear Garo:*
>
> *In thinking over your new Multichrome pictures you showed me the other day, and which you spoke of as the latest thing in photography, it strikes me your term is misleading—for in the hands of the average photographer the process would be of little or no value whatever —whereas with the man of true art and instincts and training, there is no limit to which your discovery (if that is the right word) may be developed. I fancy I am safe in predicting a great future for your new and stunning art.*

And from New York City, Pirie MacDonald, the self-styled "photographer of men," declared, "Dear Jack: I can't get those 'color things' of yours out of my thoughts. Likeness and color with art impeccable, by photography, is like a dream—but you have realized it."[79]

Yet color portraiture was not Garo's only innovation. His experimentation with new techniques led him to his greatest medium—gum arabic. Beginning in 1911, Garo became an expert at the gum bichromate, or gum arabic, process, which required both technical skill and a sense of individual artistry. The procedure was complex and took many steps to perfect. An observer wrote the following detailed description about Garo's process:

> *Gum printing is a process of superimposed printing by which the photographer is able to "paint" his print, as an artist builds his lights and darks, beyond what actually exists in the negative.*
>
> *First, he sensitizes his own paper (previously coated*

with gelatine) with a solution of gum Arabic, potassium
bichromate and water color pigment (which gives color
to the print). When thoroughly dry, he makes his print

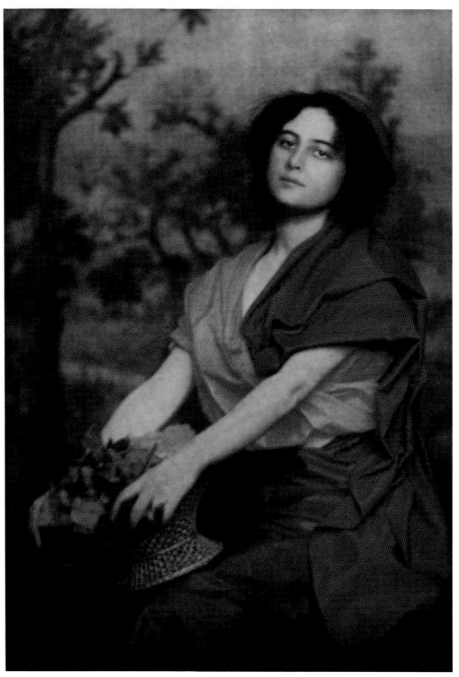

"Italian Flower Girl," by John Garo (1908)

in the usual orthodox manner. The parts exposed to the light, which would be the "darks" of the picture, become hard through contact with the light, while the less exposed parts retain the original softness.

The developing is done by immersing the print in water. The portions exposed to the light will hold their color, while the less exposed portions wash off readily. By light brushing or dripping water on the print, the highlights can be lightened, even to the white paper, as desired.

When the washing is completed, the print is dried, coated again, and the same printing and washing process repeated as many times as necessary to obtain the effect desired. The elusive part of this process is that at any washing it is possible to lose the entire image.[80]

Garo's first successful gum print was created after sixteen successive printings. Sometimes it would take Garo as many as thirty versions to perfect the piece. Most of the gums were monochrome, but Garo worked to give a warm resonance to the flesh tones. His images were captured on large-format, 14″ x 17″ or 16″ x 20″ glass negatives, and the process could take days to finish. But with patience, the end result produced exemplary work that one admirer believed offered a "great richness and physical beauty comparable only to a heavily pigmented painting."[81]

Garo's efforts were greatly admired in the photo community, and one of his unique pieces garnered special attention. It was titled *The Old Manse*, and Garo labored intensively to create the truly original image of a snow-surrounded homestead "with its hush of moonlit evening" and a "mysterious shadow quality." When G. W. Harris, the president of the Photographers' Association of America, saw *The Old Manse* he offered Garo five hundred dollars for it. And although

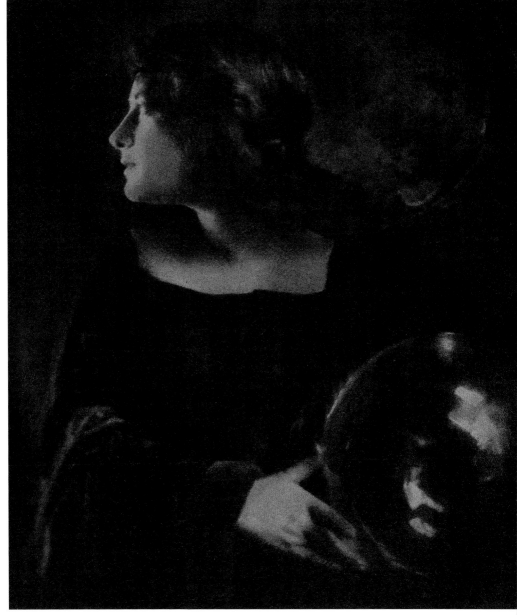

"Bubble," by John Garo (1914)

Garo would not sell his distinctive creation, the photograph became famously known as the "five-hundred-dollar picture."[82]

Garo's skills in this format were quickly recognized by leaders in the field who declared his images "neither a photograph nor a painting, but something far beyond either." When asked by one of the prominent photographic journals to submit an example of his gum work, Edward Weston told the editors that his photography was not as good

"Portrait Study," by John Garo (1909)

as Garo's and that they should print one of his works instead. George
Eastman was so impressed by Garo's output that he asked him to join
the company as Eastman Kodak's head of research and development.
But Garo declined, telling Eastman that "his primary interest was as a
creative artist rather than as a technician."[83]

Garo's innovations created a stir in the world of art criticism. His
continual blurring of the lines between painting and photography led

observers to consider the impact of his work on all artists. A. J. Phil-
pott reasoned:

> A curious thing about photography is that it never has
> made a very strong appeal to artists. The artist is rath-
> er jealous of the photograph. It does almost instantly a
> thing that costs him thought, labor, and struggle; and
> there is something of science in it which the artist hates
> to bother with. To the artist the average photograph is

Portrait of Hope Steizle Merrill, by John Garo (1923)

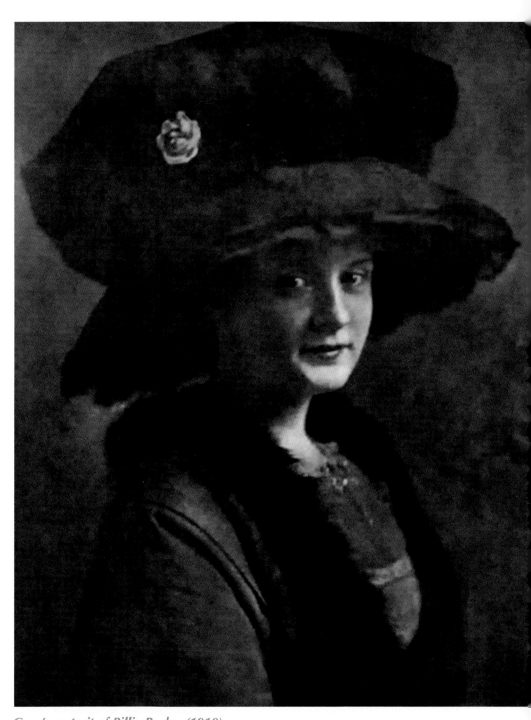

Garo's portrait of Billie Burke, (1910)

nothing more than a record. That feeling was stron-
ger thirty years ago than it is to-day, and the prejudice
against the photograph has been in measure broken
down by such men as John H. Garo.[84]

But as accolades accumulated, the ever-captious Alfred Stieglitz perhaps could not help himself as he tried to take Garo down once more. In July 1912, a new gum print portrait of Garo's was on display at the annual Photographers' Association of America's convention exhibition in Philadelphia's Horticultural Hall. When Stieglitz saw the piece he responded with "uncomplimentary criticism." Stieglitz was at this time grappling in his own mind with the differentiation between photography and art, and to him, the fault of Garo's gum work was that it was "trying to imitate painting." Soon the news of his criticism spread, and Garo received several letters from other photographers relating Stieglitz's negative response.[85]

Garo, determined to regain respect, dashed off a note to Stieglitz:

I have not the least doubt that the people did not fully
appreciate your point of view. I have been and still am
a serious student always ready for criticism. Now if you
will be good enough to tell me where I fell short and how
I could improve this effort of mine I would appreciate
it much.

A chastised Stieglitz wrote back that he would come to Boston to meet personally with Garo and discuss their different views. Garo replied that he looked forward to talking in person since trying to present his ideas in a letter was like creating "an undertimed snapshot." And in a final gracious but perhaps competitive flourish, Garo concluded, "I remain yours in Gum."[86]

"Woman Seated in Hat," by John Garo

Geraldine Farrar, by John Garo (1908)

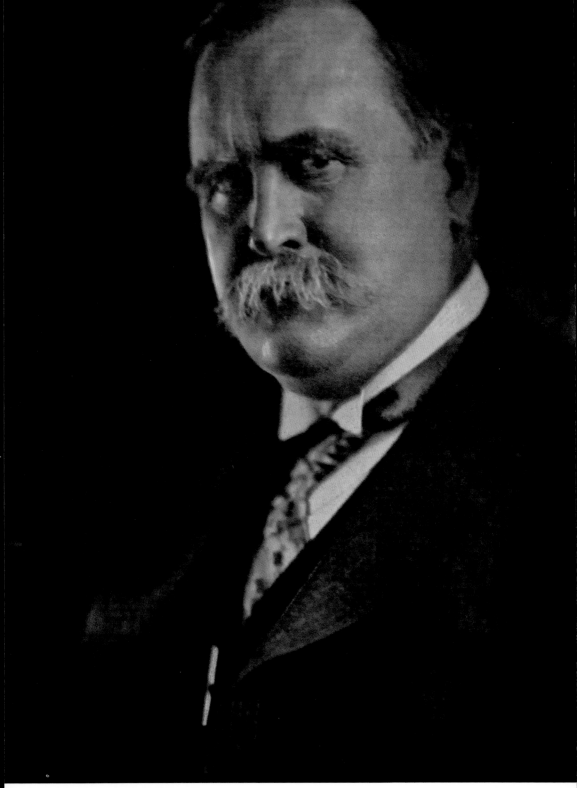

Eugene Foss, by John Garo (1916)

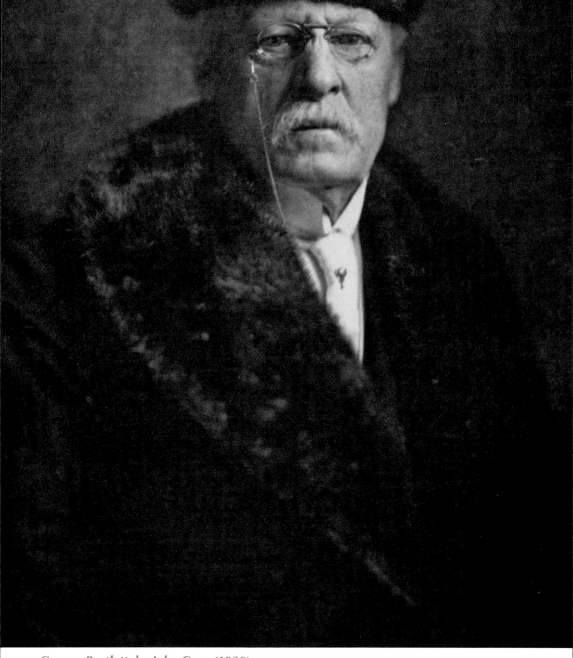

George Bartlett, by John Garo (1920)

"Untitled," by John Garo, Yearbook of the Photographers' Association of New England, *Bridgeport Convention (1911)*

Others were more impressed than Stieglitz, and the nation's most famous and influential people began flocking to Boylston Street for a portrait by Garo. The list of Garo's subjects is indicative of his broad reach and his ability to garner the attention of society's most renowned individuals. When Billie Burke, an actress best known as the wife of the musical producer Florenz Ziegfeld Jr. and as Glinda, the good witch, in the 1939 film production *The Wizard of Oz*, sat in front of Garo's lens, she joined the ranks of fellow subjects Secretary of State Richard Olney and celebrated business tycoon Clarence W. Barron, head of Dow, Jones & Company and the *Wall Street Journal.* Boston's archbishop, Cardinal William Henry O'Connell, and Mayor James Michael Curley came to Garo for their portraits, as well as the loftiest of Yankee Brahmins, Secretary of the Navy Charles Francis Adams III, and Moorfield Storey, the inaugural president of the NAACP.

Some of the other luminaries that graced the Boylston Chambers studio included actress Ethel Barrymore; artist John J. Enneking; Congressman Samuel Leland Powers; soprano Carmen Melis; poet Juan Ramón Jiménez; astronomer Percival Lowell; tennis champion Richard D. Sears; writer Elbert Hubbard; Massachusetts governors John Davis Long; Curtis Guild; Channing H. Cox and Eugene Foss; sculptors Bela Pratt and Henry Hudson Kitson; Postmaster General George von Lengerke Meyer; architect Ralph Adams Cram; presidential kin Franklin Delano Roosevelt Jr.; pianist Jesús Maria Sanromá; and opera star Geraldine Farrar.[87]

In 1914, Garo was honored as the first American to receive an invitation to show his pictures at the London Salon of Photography's exhibition in the galleries of the Royal Society of Painters in Water Colours. Continuing to break down the barriers between the old and the new, that same year Garo was also the first photographer to exhibit at the prestigious Boston Art Club. The exhibit was highlighted by Garo's "pictorial imagination," and critics wrote that previously "it

*Cardinal William Henry O'Connell,
by John Garo (circa 1906)*

would have been pointed out that his process was entirely mechanical, and that any creative artistry was out of the question in photography. *Nous avons changé tout cela!"* The show was so well received Garo was invited to return two years later for another show.[88]

At Garo's 1916 show at the club, another observer remarked:

By using the multiple-gum process, Mr. Garo has at his command a means of artistic expression that, in his hands, is searching, flexible and effective, and enables him to produce pictures which, though in monochrome, rival in subtlety, power and impressiveness the finest work of the painter. In accuracy and beauty of modeling and anatomical truth, alone, these gum-portraits of Mr. Garo's would seem to have the effect of discouraging the professional portrait-painter, to whom they appear as a revelation of an entirely new art. Conventional lighting was thrown to the winds. Unusual but legitimate plays of light were utilized to bring out individual traits of character and expression, whether executive force, imagination, combativeness, cynicism, vacillation or sensuality.

Edith Nourse, by John Garo (circa 1896–1907)

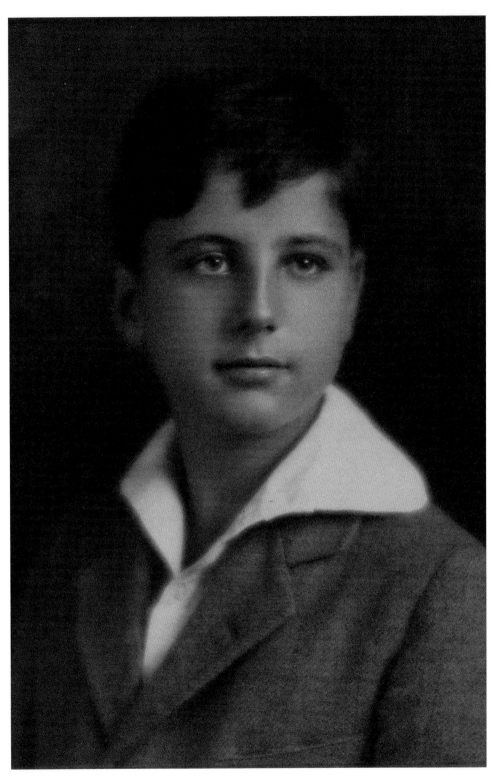

Left: Portrait of a young boy, by John Garo

Right: Martin Papazian, by John Garo (circa 1905)

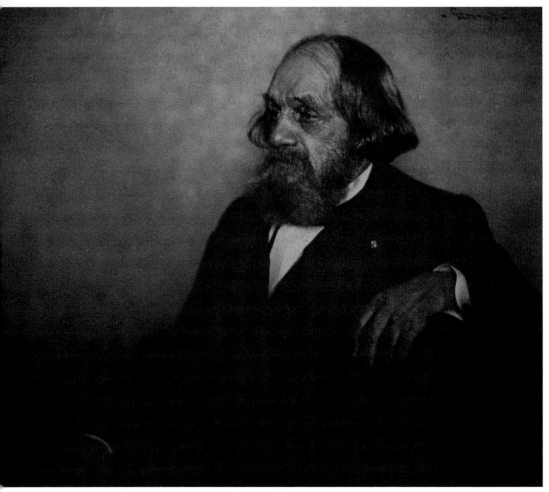

Portrait of Edward Everett Hale, by John Garo (1916)

And after years of refusing to recognize photography as an artistic endeavor, the Boston Art Club finally admitted the greater recognition Garo had achieved and made him a full member of their organization. Photography had arrived at long last in Boston![89]

Garo was now accepted in the highest Yankee circles but kept true to form and attended many formal functions dressed more like an artist than a businessman, declaring that he "never was a Tuxedo Dude." He was a frequent lunch guest at the Harvard Club. He joined the Masons and became a member of the Knights Templar and St. Paul's

Royal Arch Chapter. Garo was even asked to join the exclusive men's club that had once denied him membership due to his ethnicity. But Garo's reply was, "When your ancestors were still swinging in trees mine were building temples."[90]

The Armenian community was exceedingly proud of one of their native heirs. Winning awards and gaining fame, Garo was a hero to his fellow emigrants to the U.S. who were struggling to unravel the mysteries of American life. Here was one of their own who was able to acknowledge his heritage and still succeed in elitist Boston. One admirer, Haig Adadourian, wrote to the *Boston Herald*:

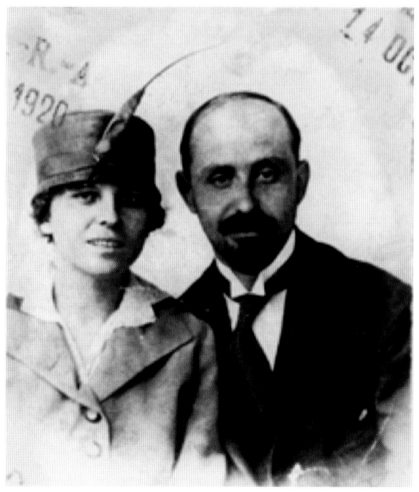

Wedding portrait of Juan Ramón Jiménez and Zenobia Camprubí, by John Garo (1916)

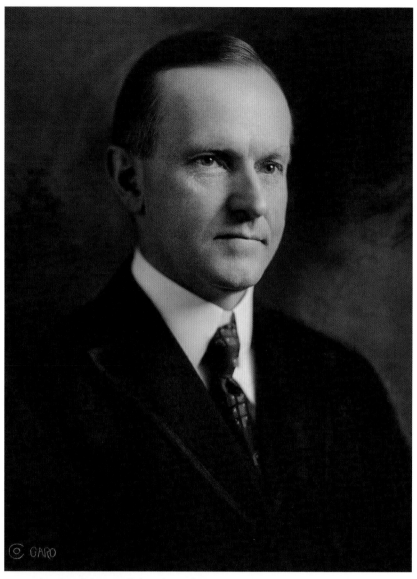

Portrait of Calvin Coolidge, by John Garo (1923)

> *Thousands of his fellow-Armenians resident in America*
> *and elsewhere are proud of Mr. Garo and of his artistic*
> *achievements. They take a pardonable pride in him for*
> *his national and international fame as a photo artist.*
> *While he himself is proud of his American citizenship,*

he is also proud of the Armenian blood flowing in his veins. . . .

Occasionally we read in the daily press about the disgraceful deed of some lawless person and are painfully and pointedly reminded that the villain belongs to the Armenian race. As a counteracting and compensating fact we joyfully point to Mr. Garo and to scores of American citizens of Armenian extraction who have been signally successful in various artistic, scientific, industrial and commercial pursuits, and who are a credit both to America and to the Armenian race.[91]

Others were touting his success as well, and the critics seemed to make Garo an instant master. He was compared to the likes of Rembrandt, Gainsborough, Corot, and Vermeer. His landscapes were equated with van Ruisdael's and Constable's, while his portrait of clergyman and author Edward Everett Hale was described as "a triumph, and if it were in colors it would rank with Whistler's 'Mother.'" But there were limits to comparisons, and when one aficionado likened one of Garo's creations to the *Mona Lisa,* an incredulous Sadakichi Hartmann had to weigh in:

Portrait of photographer Nussbaum, by John Garo (1901)

That is neither criticism nor appreciation, but simply swash. . . . A monochrome print cannot be compared to a life-size painting. It is illogical, childish, and futile. . . . It hurts the photographer as much as the man who writes such stuff.[92]

But although Hartmann could be "whimsically cynical" and "frequently sarcastic," he was a true fan of Garo. Thinly disguised by the pseudonym of Sidney Allan, he visited Garo in Boston one misty afternoon and wrote about his experience:

Quite accidentally I strayed to Jack Garo's studio, and there the somber mood was dispelled as if by magic. One does not mind the weather when one is in Jack Garo's studio. Surely this is no studio of the ordinary sort. No chamber of horrors. The true artistic spirit prevails. The rooms have temperament. There is nothing, except the camera and a few screens, to remind one of the workshop of the photographer. And Garo was painting, really painting, not tentatively like an amateur, but plying his brushes with the dexterity of a professional.

"Have you turned painter?" I asked, quite surprised at the beauty of the little landscapes that stood on the easel.

"Oh, I just paint for a pastime. Some day I may do something worthwhile." That was the modesty of the true artist, who endeavors to express himself, who never believes that his work is perfect and that the next effort might not be superior to the present one. . . .

"But if you can paint so well, why do you make photographs?" I queried.

"Because there are certain things that can be expressed best by photographic process. Photography is merely another medium for artistic expression."[93]

It was through this medium that Garo was able to represent not only his "subjects' features or anatomy but also their psychological and emotional personalities."[94]

"Art study from model," by John Garo (circa 1910)

Portrait of Tenor Roland Hayes, by John Garo (1930)

One of his most famous photographs was his 1923 portrait of Calvin Coolidge, in which he perfected the image over ten successive printings using the multiple gum bichromate process. The painstaking process resulted in a masterful photograph, in which "the surpassing technical excellence of the portrait is pleasingly manifest and plainly demonstrates the supreme skill of the artist." Coolidge had turned down an offer to have his portrait painted by John Singer Sargent and went to Garo instead. The resulting image was described as possessing

"qualities not unlike an oil-painting," illustrating Silent Cal's "attributes of morality, wisdom, clearness of vision, personal courage and firmness of decision." Garo sent the portrait to Mrs. Coolidge in time for Christmas. Upon receiving it, she declared it to be her favorite likeness of her husband and hung the portrait in the White House. Garo in turn proudly hung a letter from the president in his studio.[95]

Garo had reached the pinnacle of his career. Photography had provided the means to his professional ascendancy, and the reputation and reception of the art had ascended with him, thanks to his skill. Respected as an artist and successful in business, the Armenian immigrant had at long last achieved the American dream.

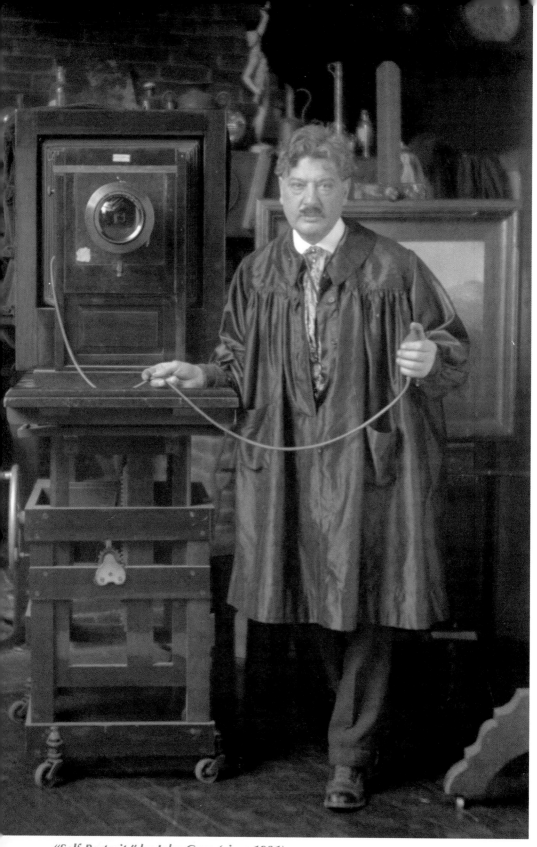

"Self-Portrait," by John Garo (circa 1931)

Chapter 4

DOUBLE EXPOSURE

The early 1920s were good times for Garo. His family life was in harmony, his portrait of the president was hanging in the White House, and his recognition as both a photographer and artist could not be challenged. When a reporter stopped by Garo's studio, he found a person filled with a positive sense of life:

> *Some Boston businessmen engulfed in work are always so cheerful they make you wonder how they do it. "Jack" Garo, the Boylston street photographer, has the secret. Jack says he wasn't born an optimist, neither did he acquire optimism. It was and is according to him because of the big and all-inclusive interest life has for him all the time. In other words, Jack's dope is 'love living life, and the things it endears for their own sake and you will radiate optimistic magnetism without the consciousness of doing so.'*[96]

Untitled, by John Garo (1918)

Garo's lightness of spirit complemented his search for creativity and inspiration. Although he did most of his lenswork inside the Boylston Chambers studio, he believed in the beneficial effect of new surroundings, instructing fellow photographers to spend time outside:

Go out of doors for inspiration, then you can find the immense and varied nature in all its different moods. This is where your soul can feed and expand. For a time, close your studio behind you. Above all, when you return be sure that there is a bit of sun-light in your soul and some ambition in your heart.[97]

Following his own advice, Garo continued to photograph and paint, often going in the spring to Jamaica Pond, the Blue Hills, or the Fenway area, and "catching the spirit of nature on his easeled canvas." In his landscape photos, Garo sought to present "the interpretation of a mood rather than an actual scene." And Garo's landscapes were unearthly at times: "the lack of vivid contrasts in light and dark promote a feeling for death and, therefore, throughout these landscapes there is a flatness of surface that makes the photograph more decorative and less realistic."[98]

In order to perfect the image he was seeking, Garo would often

visit a place repeatedly to paint the same picture from the same view-point on different days. One of Garo's artistic escapes was a trip every summer to Hillsboro, New Hampshire, where he spent a month at a cottage "just painting." There, he and Alice had good friends in the photographer William Manahan Jr. and his wife, Ethel, whom Garo had met through their joint connection with the Photographers' Association of New England—both having served as presidents.[99]

Garo was once described by a critic as "the one professional photographer I know who can draw and paint, make an interesting sketch, as well as actually finish a life-size portrait in oils." Garo's endeavors

Dean LeBaron Russell Briggs, by John Garo (1925)

"Woman with Ribbon in Hair," by John Garo (1912)

in painting continued to inform his ideas about photography and vice versa. His technique for portrait photography captured what painters called the "lost edge"—a sense of roundness that contrasted with the usual flat and sharp image common to most photographs of the day. Garo himself likened his photographic work to painting:

> There are a good many artists who do not fully realize that the camera has artistic possibilities and that in the hands of an artist the lens is just as efficient means of artistic expression as the brushes and pigments of the painter. Instead of using pencil or paint, we draw with light.[100]

Garo even believed that photography was, in a way, superior to other forms of art:

> The one outstanding characteristic of photography—the quality that distinguishes it from drawing, painting, etching, or any other means of pictorial representation—is the ability of the lens and sensitive film to record infinitely delicate and subtle gradation of tones. This is where photography is supreme and it is because of this qual-

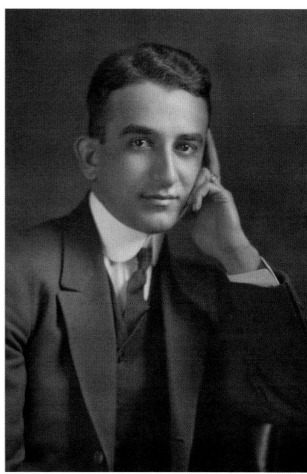

Portrait of John S. Tomajan, by John Garo

ity that photography claims and holds a place among the fine arts.[101]

Music also influenced Garo's work. Often the phonograph would be playing in the studio as Garo joined in singing complete arias from *Aida* or *Rigoletto*, "never anything light," or joined Enrico Caruso and Antonio Scotti's duet to form a trio in *La Forza del Destino.* Music was crucial for Garo, and he often introduced musical terms into his discussions of photography, describing studio backgrounds as "the accompaniment to a solo" or comparing the creative works of the lens to that of a piano claviature. For artistic inspiration, Garo even wrote music in a little sketchbook—chromatic music, no less.[102]

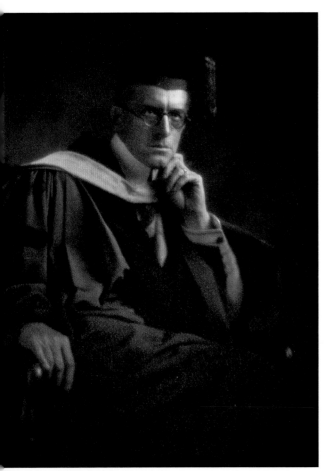

Surrounding himself with figures from the world of music, Garo photographed the famous Boston virtuosos and maestros of his day, including violinists Willy Hess and Karl Wendling; concertmaster Anton Witek; and conductors Max Fiedler and the better-known, unrelated Arthur Fiedler. Another associate and customer of Garo's was Karl Muck, the conductor of the Boston Symphony Orchestra, who was held in high esteem in cultural circles.[103]

As the decade progressed, Garo's name continued to be acknowledged throughout the

Ralph Adams Cram, by John Garo (1916)

From left to right: John Tomajan, his sister Bessie (Elizabeth) Tomajan Papazian, her son (lap) Martin Papazian, Bessie's husband Charles Papazian, and their daughters Gladys (sitting) and Marion Papazian, by John Garo (circa 1910–1912)

profession. His works were routinely displayed around the country, and some notable exhibits included the Baltimore Museum of Art and the National Museum, a show described as one that "will well repay a visit." Garo was not immune to criticism, though. In 1924, when one of his exhibitions appeared at the Camera Club in Manhattan, the *New York Times* critic gave the show mixed ratings and commented that the "landscapes are not particularly distinguished" and the "one or two prints of women are sentimental and soft in line." And in a dinner in New York at which he was the guest of honor, Garo was introduced as "the boy of yesterday, the workman of today," and his talk was subtly critiqued as being in "best form with citations from his early efforts as a photographer."[104]

Garo was unconcerned with trends, continuing along his own artistic path, according to his own interests. However, the encouragement he had always received from colleagues and contemporaries in Boston had begun to wane. The outbreak of the Great War had interrupted the progress of the Boston Photo-Clan, and it became difficult and expensive to obtain many of the photo-processing materials that came from Europe. By the early 1920s, the photo-clan had "long since ceased to be an active force" in the world of photography.[105]

Old pictorialist pals such as H. Oliver Bodine and Henry Eichheim had departed Boston by this time—the former moving over to the motion picture industry and the latter following his interest in Asian music. Garo's household grew quieter with the departure of nephew John Tomajan, who had lived with the Garo family for seven years while studying at Harvard. With no children and most of the family in the Worcester area, Alice and Jack felt a bit detached as the decade progressed.[106]

As Boston's demographics changed, Garo's business with the old Yankee establishment decreased. He closed his other branch locations and concentrated on maximizing his work at Boylston Chambers. He still experimented in the print room with his gum arabics, joined in the resuscitation of the International Congress of Photography through reform in the mid-1920s, and continued to participate in shows with the Photographers' Association of the Middle Atlantic States in Philadelphia and the Appalachian Mountain Club.[107]

However, the hum of the Hub had slowed perceptively, and Garo had too. Time in the studio gave Garo pause to think about his increasing isolation and the lack of energetic connections he once maintained with the Boston Photo-Clan or the Photographers' Association of New England. There were fewer and fewer people to talk shop with, and aside from Miss Ames, who was by now fifty years old and still living with her mother, the celebrated salon seemed empty much of the time.[108]

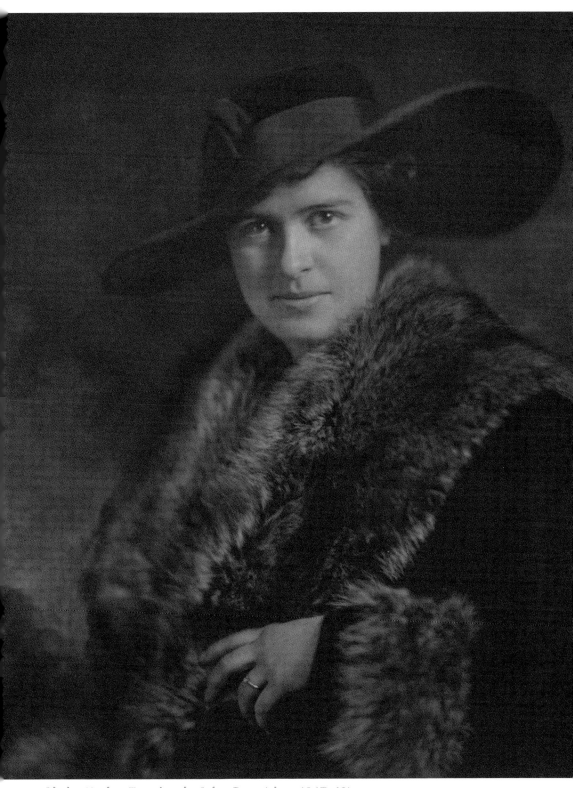

Gladys Harlow Tomajan, by John Garo (circa 1917–19)

Russell Tomajan, by John Garo
(circa 1905)

Uncle Garo with little John Garo Eresian
(circa 1932)

In 1928, Garo's friend and fellow Armenian photographer, George Nakash, reached out to Garo, asking him whether the master would be willing to take on an apprentice. Nakash was from Mardin, Turkey, but had fled to the U.S. and eventually moved to Sherbrooke, Canada, to open a studio. In 1921, he encountered Garo when he entered a photo contest in which the Boston dean of the darkroom was a judge. Later, Nakash sponsored his immigrant nephew Yousuf Karsh, who himself had escaped Turkish persecution. Nakash asked Garo whether he would help his young family member who showed signs of talent behind the lens. Needing to be persuaded, Garo eventually became intrigued at the thought of being a mentor and after some time agreed.[109]

But there were preconditions to the arrangement—Karsh was to stay for a period of only six months, had to purchase his own materials, and would receive no compensation while working for his new tutor. Arriving in Boston, the nineteen-year-old Karsh presented a picture that contrasted greatly with Garo's theatrical and cosmopolitan

mastery of human affairs. Diminutive in stature, reserved, speaking little English, and awed with the notion that he had come to America with "the sensation of being sent to study under a Michelangelo," Karsh did his best to begin to understand Garo's work.[110]

At first it was difficult for Karsh, thrown into an atmosphere of highly technical expertise. Garo's labors, especially in the darkroom, were instinctive. He developed his images not by science but rather by intuition. A visitor to the salon related to Karsh,

> *I remember being up there one day and [Garo] had a beautiful setup of glass and silver and 11 x 14 color plates in the camera. He took a belt punch and punched a hole in a card and shoved it into the lens for a stop and I wondered how the hell he would know how long to give it. He pulled the slide and we went into the darkroom and had a drink . . . and then smoked cigars until we got near the end of them. Then he said, "I guess that's*

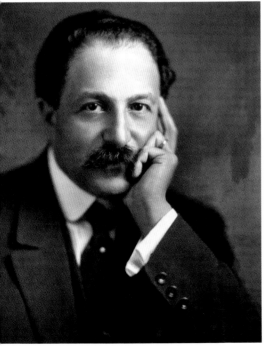

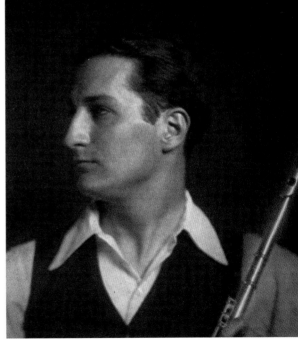

Pierre Monteux, by John Garo (circa 1919)

Laurent Torno, by John Garo (1927)

enough," shoved in the slide and we took the platehold-
er into the darkroom. By my wristwatch I noted that 42
minutes had elapsed but he had never looked at a clock.
Then he developed one of the handsomest transparen-
cies I ever saw. The timing was right on the nose. . . .
Garo had no formulas and never weighed or measured
anything.[111]

Karsh worked hard in the Boylston Street studio. In attempting to replicate some of his mentor's work, it once took him eighteen days to produce one photo. Garo was "a perfectionist," and when Karsh showed off some of his creative endeavors, the elder lensman was quick to deliver strong critical commentary. Karsh related, "Where a compliment was deserved he never withheld it, but I do not remember many causes for jubilation on my part, in the early days at least." At times, Garo boisterously corrected Karsh's broken English and laughed heartily at his mistakes.[112]

But after a while, Garo seemed to warm up to his understudy. He had always sustained a soft spot for less experienced photographers trying to stake their artistic claim in life. Garo would often attend exhibitions by amateurs because he found them "intensely interesting and instructive," and he firmly believed it was his "duty to encourage the young people." It was in this spirit that Garo and Karsh began to form a bond that transcended the traditional teacher-pupil relationship.[113]

At the end of the first six months, Garo asked Karsh to stay and offered him a salary of twenty-one dollars a week—a solid wage for an apprentice in any field in those days. Garo insisted too that Karsh use the money to take English lessons to improve his communication skills and drawing classes to help refine his appreciation for the human form. While Karsh came to the conclusion that he could not "draw a

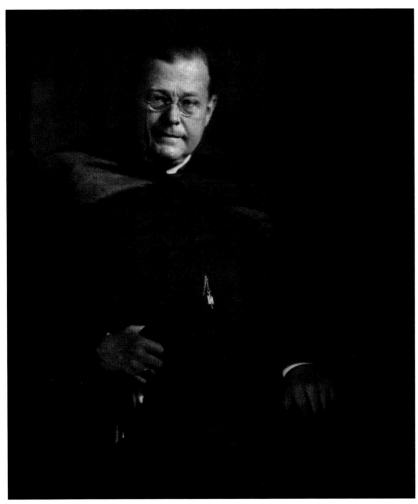

Portrait of Reverend William van Allen, by John Garo (1920)

straight line," he did utilize the art course to help him better under-
stand modeling, lighting, and composition.[114]

Garo also made sure that Karsh had some level of general educa-
tion. Garo took his young understudy to the Museum of Fine Arts, and
within its walls Karsh began "to understand beauty." He also walked
with Karsh to the Boston Public Library, where the apprentice became
a "voracious reader" of many subjects. At the library, Garo encouraged
Karsh to study the reproductions of the great master painters such
as Rembrandt and Velázquez to understand their use of shadow and

color. Karsh could also see Garo's work on display in the stately music room of the library, where Garo's portrait of philanthropist Allen A. Brown hung. And back at the studio, Garo would review the same images with Karsh, pointing out by photographic memory some subtle feature that the student had missed in his own analysis.[115]

It was at the library that Karsh also began to explore the faces and figures of living individuals who crowded through the hushed building. Overcoming his "great natural shyness," Karsh would invite a stranger to Garo's studio so that he might make a portrait of a unique subject. The next day the master and the pupil would review the photograph and discuss the merits and shortcomings of the work. Later in the morning, Karsh would often shadow Garo in the studio during a sitting, observing the "sharing of truth between the photographer and his subject." It was here that Karsh believed that he learned "a tremendous technical discipline . . . light control," for which Garo was renowned.[116]

But it was in the darkroom that Karsh first and foremost enjoyed studying the elder cameraman's gum arabic masterpieces. The collection of 14″ x 17″ or 16″ x 20″ prints provided a continual source of inspiration to the young student. Karsh was fascinated by the work, describing them as the "most permanent portrait medium yet discovered" and "a tremendous achievement measured in fantastic patience and skill in the developing process, and beauty in the result."[117]

Garo's technical proficiency was unique, and Karsh relished his education, especially as Garo worked his magic in developing images. The darkroom was the seasoned lensman's laboratory, his sanctuary where few had the privilege of watching him employ very slow emulsions to transform a moment captured by the camera into art. As Karsh observed, his mentor patiently and deftly performed his alchemy, always with a sparkle in his eye.[118]

In the darkroom Garo freely shared with Karsh the secrets of

his master prints and provided him with the most formal course of study. Karsh learned the ways of gum arabic and of platinum printing, carbon oil, and bromoil procedures. And with every specialized lesson, Garo imparted his own technique, often lecturing dramatically to Karsh:

> Reflect before you expose a plate. Don't expose carelessly, relying on averages through a series of exposures. Make each as perfect as you can. Understand clearly what you are seeking to achieve, and when it is there, make your exposure. Art is never fortuitous. Remember that on every exposure you make you expend energy and thought; respect them.[119]

Garo emphasized throughout that technology itself was not of the greatest importance; it was how this science was used: "Good penmanship does not make good poetry. If one has nothing to say the lens will not tell it for him." He continually pressed Karsh to understand how to engage the images he saw and ensure that they would not be "lost in the mechanical processes that are part of photography." He also mandated that Karsh fully comprehend the "so-called rules of composition" so that when the photographer broke these rules, he did it purposely.[120]

But Karsh still struggled to grasp all that Garo had to offer. The apprentice realized that "Garo could not explain his art completely; few great artists can." The technical expertise that came with decades of experience was not something one would absorb in a year or two. Garo was patient, though, and content to see his pupil mature professionally over time. A bond between the two had grown, and Garo relished his decision to keep Karsh at his side.[121]

Along with the important studies in the studio's sitting area or in

Halloween party at Garo Studios; Garo, as host, is seated in bottom row, center

the darkroom, Karsh was being tutored in understanding the human spirit. Aside from lessons in photography, Garo was also giving an invaluable "education in the humanities." This education was chiefly accomplished through his exposure to the city's cultural and civic leaders who visited the Boylston Chambers studio to experience Garo's hospitality.[122]

To compensate for the slowing workload and to illustrate his free spirit in the face of Prohibition, Garo began having parties at the Boylston Street studios during the 1920s. When the sun fell around four o'clock in the afternoon and Garo could no longer photograph using the natural northern light, spontaneous gatherings would occur. Illegal liquor was concocted in the darkroom by adding gin, rye, or bourbon flavoring purchased at a drugstore to alcohol brought to the studio by a local bootlegger who smuggled his wares in turpentine tins. Depending on the moods of the guests, the conversation would run from "stimulating and . . . serious" to "very frivolous."[123]

Other affairs would be planned long in advance, with Alice acting as gracious cohost. There were costume parties with scores of invited guests or a special soirée arranged for the visit of a renowned actor or musical figure. The parties would continue into the late hours, with those assembled joining together in song to close the evening. An observer noted that "Garo, the bon vivant, connoisseur, baritone, and legend-weaver, would revel among his friends with a charming affability. Here, one would meet symphony conductors, playwrights, impresarios, tycoons—men of mark—who could give-and-take in sparkling repartee."[124]

The festive afternoons and evenings made for great camaraderie, and Karsh was present to observe and absorb the discourse of these luminaries who visited the studio. Here was Enrico Caruso, Serge Koussevitzky, or Arthur Fiedler performing music; newsmen from the *Boston Evening Transcript* talking about journalism; or an architect comparing contemporary buildings with structures from ancient Babylonia; the whole world of arts and letters congregated in Garo's

Costume party at Garo Studios (circa 1925); Garo, the host, is at bottom, third from left

studio. Karsh saw it as the "richest part of (his) post-graduate education" and believed that "Garo's salon was my university, a noble institution at which to have been permitted to study."[125]

The young Karsh was fully in the midst of these gatherings and participated by serving as a bartender, "which service Garo seemed to associate with the handling of chemicals used in his developing room." With dramatic flourish Garo would herald his understudy: "Now for Dr. Koussevitsky, Yousuf . . . let us have some nitric acid," which was code for a gin and tonic. This would be followed by another rousing call: "And for Arthur Fiedler, some hypo," which was *le nom de guerre* for bourbon.[126]

In Garo's presence, the youthful immigrant felt inspired to come out of his shell and truly be a part of the scene. Karsh became "accustomed to celebrities" at Garo's studio, seeing them in many ways as regular people. Through this process he became enured to status or fame associated with certain personalities and interested instead in their accomplishments; it was the beginning of his focus on those who were "great in spirit." This exposure to society's leading lights propelled Karsh to set his "heart on photographing those men and women who leave their mark on the world."[127]

Karsh continued to experiment in his work at Garo's studio with new ideas of how best to preserve the memory of the subjects whom he photographed. One day, Karsh had completed a new portrait of a middle-aged man and showed it to Garo. Unsatisfied with the work, Garo remarked, "Come along with me, Yousuf, and I will show you what I mean." Outside, in front of the Boston Public Library, the older lensman gave Karsh an extended lecture on how natural light and shadows against the structure offered an example of proper composition. Comparing the photograph with the natural beauty of the building, Garo indicated how Karsh's print had "failed."[128]

However, Karsh countered by saying, "But you have said often . . .

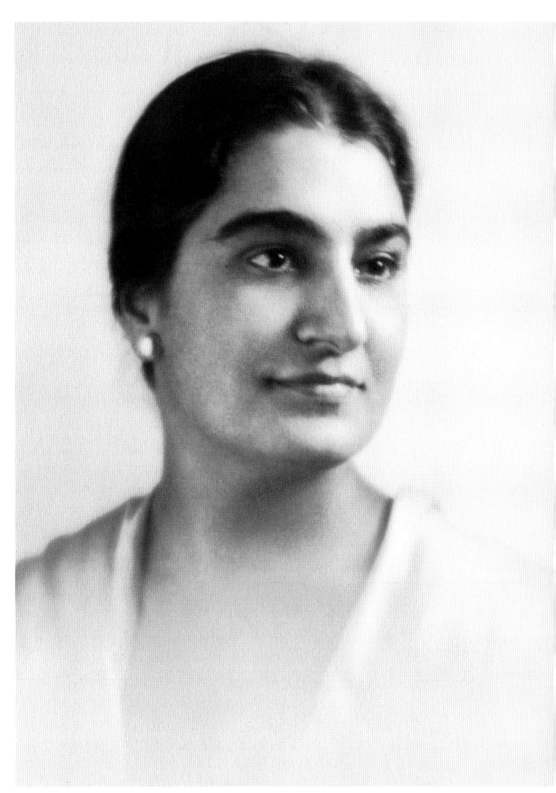

Portrait of Rose Davidian, by John Garo (circa 1930)

that when I make a portrait, even though I use the same colour and same materials for the same subject as you do, yet I may see something different." Garo's reply was simple and succinct: "That is the most valuable thing you have said, Yousuf." A symbolic summit in the photographers' relationship had been reached. At that point Garo had given everything he could to Karsh. And the two had become equals, realizing that each had his own trail to blaze.[129]

After three years in Garo's studio, Karsh was thinking about leaving Boston and establishing his own studio. Garo asked him to stay longer, even declaring that Karsh "would take over his work." But the young cameraman decided he wanted to branch out into new technologies and make his own way working with artificial lighting instead of relying extensively on natural illumination. Karsh also realized that as much as he had learned from Garo, he still needed to find his own distinct voice: "I sought originality. A photographer who wants originality must not copy from anything. His work must be individualistic."[130]

Garo had always felt strongly about photographers discovering their unique identity. Years before he had written:

> Individuality is the chief equipment of the artist, and definite personal expression his distinctive merit. It is individuality and character in works that have created the large variety of schools of art. It is the character and individuality in works of art that designate Tintoretto from Rembrandt, Velásquez from da Vinci, and many others. Why should not this be realized in portrait photography? If a brother struggler happens to hang a picture on our walls, and if we fail to understand it, is there any reason why he should be ridiculed? Do we know it all? Woe to him who does! I admit we are often governed by set rules of technique, and there is the evil

which we must of necessity overcome. He may be the very one to introduce an entirely new school, for has not all art and any work of importance had a beginning? Personally, I would rather see fifty crude things through which the maker's soul shines than see one thousand so-called finished things, each the echo of the other.[131]

And so despite great reluctance at losing his closest friend, Garo realized he could not keep the young photographer from pursuing his dreams. Garo saw that Karsh was determined to take what he had learned and create something new from that knowledge. One day, the master artist spoke honestly to his student: "If you copy me, you will have learned nothing." And with that, Garo released Karsh, who made his way back to Canada.[132]

After leaving, Karsh returned to work for his uncle George Nakash and then journeyed to Ottawa, where he began his own proprietorship at the Hardy Arcade building on Sparks Street. Garo missed Karsh dearly and kept up a correspondence with the fledgling photographer. Still fulfilling the role as tutor, even from afar, he endeavored to encourage the struggling young cameraman: "It will take some time to get used to new conditions so just keep up your courage and keep on the good work. Everything here is as you left it—not much doing yet. We do not know what is ahead of us—so, why worry?"[133]

It was a message that embodied Garo's essence of being. He continued to be the lifelong optimist imparting sanguine advice for the future. And Karsh absorbed and carried this mind-set with him as he worked to establish his own career.

Portrait of John Garo, by William Manahan (circa 1925)

Chapter 5

DARKROOM

With Karsh departed from the scene, Garo settled down into a regular pattern. Keeping true to his maxim that "the only way to become successful is to help others to success," Garo decided to continue mentoring younger photographers, though at a less intense and formal level than he had done with Karsh. Some photographers who frequented the Boylston Street studio included other Armenians, such as local notables Oda Odian, Sony Yerganian, and Assadour Arzoumanian, as well as Arthur Griffin, who went on to a fine career as a staff photographer for *Life* and *Time* magazines. In keeping with his blending of photography and art, Garo was also a teacher to Rockport-based painter Giragos der Garabedian.[134]

Garo had learned how to preserve beauty for others to enjoy, and he relished in relating his discoveries to his understudies. He was never proprietary, always generous with his ideas and techniques, even with would-be competitors whose success might impinge upon his commercial livelihood. When the Great Depression closed in on the nation, Garo shared with the public the important lessons life had taught him:

Truth and beauty are closely connected and those of us
who are sensitive to beauty often find much of it in or-
dinary and commonplace objects and scenes. There is
beauty everywhere around us, if we are capable of ap-
preciating it; very often it is found even in the streets of
a big city. The sky at sunset is often wonderfully beau-
tiful, yet many people cannot appreciate it. The beauty
of a picture depends on the truth with which the picture
maker suggests to others the impressions that affected
him and which led him to treat his subject as he did. A
picture that does not touch the imagination is not in an
art sense a picture.[135]

Beginning in the winter of 1933, Garo offered classes in photogra-
phy to increase his income. But over the years, fewer people attended
them as Garo's technical innovations became outdated. While Garo's
work had once been groundbreaking, by the mid-1930s he had failed
to keep up with the changes in the field. The days of the photo's soft
edge and ethereal mood had yielded to the sharp realism practiced by
modernists like Edward Weston and Imogen Cunningham.[136]

Garo felt out of step with some of the new technological develop-
ments that were overtaking the art and compared himself "to a person
who had always played classical music and was asked to play jazz."
Having worked so hard to create consummate formats like gum arabic,
Garo had undoubtedly achieved his goals but had not set new ones for
himself. While he had once declared, "Unless we free ourselves from
the bonds of tradition we will always be the echo of the past," he had
now succumbed to the peril he had warned against.[137]

Coupled with Garo's stasis in style was his general lack of com-
mercial sense. Garo was always described as having "but little concern
for the strange, irregular rhythms of business" and more focused on

"Sunshine," by John Garo (1937)

"Study #1," by John Garo (1914)

creativity than capital enterprise. He was known to have said, "Sometimes I make pictures not for money, but for the love of it." This attitude might have been slightly tenable during the heyday of Boston's bright economy in the 1920s, but by the 1930s it proved to be the source of his downfall.[138]

At one time, Garo had fantasized about opening his studio "solely to those who desire original work" in order to prevent "degradation . . . from ordinary routine portraiture." Now, however, Garo was taking business from wherever it materialized. He started commercial work for various companies, including photographing men's footwear for the United Fast Color Eyelet Company and doing advertising shoots for a firm selling women's "corrective garments."[139]

Garo tried many angles to drum up business. He worked with professional service companies that attempted to bring members of different organizations, such as bar associations, to his studio. He accepted an offer to handle commissions for a company in St. Louis that specialized in alumni photos. But after several years very little business had been generated, and Garo declared the job "a total loss of time and energy." Garo even reached out to the greeting card companies, his original line of work, offering to do photography jobs for them. But because of his unique technique, one company "had a great deal of tough luck in reproducing the floral subjects," and the executive bluntly informed him that it would "be necessary for me to find a better price then twenty-five dollars a piece for each subject."[140]

Garo began writing letters to customers he had not seen in years, inviting them to come in for a new portrait or buy an original exhibit print. But the bad economy affected business relationships in a multitude of ways. Garo found his customers could no longer afford to see him, and instead of making appointments for a sitting, they returned his letters of appeal with criticisms of his writing skills. Garo was so starved for income he even offered to sell his valuable negatives to the customers he thought could afford them.[141]

Despite the rebuttals, Garo persisted—opening his gallery for a show of etchings by Lester Hornby, holding an exhibition for the International Salon of Photography as well as the Massachusetts Photographers' Association, and offering to display works of painters such as William Lester Stevens. He sent promotional letters to the Boston-area professional schools for young women, offering portraits at a discount. During the mid-1930s he continued to work the circuit, lecturing at the Maine Photographers' Association and as the honored guest at the Worcester Photo Clan's dinner in 1935. In a sign of renewed aspirations, Garo hired someone to make improvements around the studio, applying a fresh coat of paint, and installing a new skylight. Garo even reserved a booth at the Greater Boston Camera Exposition in the hope of gaining new exposure.[142]

But despite his efforts, business tapered off dramatically. Garo now had only sixty customers a year. The studio was quiet most of the day. Often the only figure in the studio was the life-sized bronze bust of Garo, a monument by William Clark Noble, who intended to "put into imperishable form" the man who had "won distinction in photography as one of the fine arts." The statue, once exhibited at the Museum of Fine Arts, was conspicuously silent when Garo needed company. Garo inquired of a friend how to write a letter to customers informing them that he was dropping his prices. The sales offer did little to help, however, and things worsened. Writing his niece Frances Eresian, at the start of 1935, Garo related:

> I have had a hectic time. Just before Christmas I let Miss Ames go, therefore I was alone a long time without anybody, so in doing my work for Christmas and doing office work, answering phone calls, I was fit to go to the crazy house. . . . Just now things are very quiet. I am looking for a good 1935, I hope I will not be disappointed.[143]

"Miss R," by John Garo (1909)

"Oval Portrait of a Woman," by John Garo

Yet Garo's troubles continued into the new year. When suppliers contacted him, he admitted that, "under the present economic conditions it is utterly impossible for me to think of purchasing anything." And in Garo's worldview, the inability to maintain a business relationship was more than a temporary interruption in commerce; it was a personal failure, for he believed "the time one is most anxious to help a friend is the time one is not in a position to do it."[144]

Eventually Garo could not afford to pay his membership dues for several of the organizations he had been a major force in developing. The Boston Camera Club wrote him in March of 1935 informing him that he was delinquent in his payment of three dollars and that they would be forced to drop him from the rolls if he did not reply soon. When Garo informed them that he would not be able to come up with the funds, the club graciously elected him an honorary member. The elite Boston Art Club was not so generous and sent him a letter warning him to send at least a partial payment before they sent a draft notice to Garo's bank the following week. The high priest at the Masonic temple was almost apoplectic at Garo's delinquency, declaring, "WHY have you not answered the letter . . . in regard to your dues for Saint Paul's R. A. Chapter? . . . I want to play ball with you, will you play with me by answering this letter immediately?"[145]

Karsh was perhaps Garo's most loyal supporter and confidant during this rough period. The friendship they had cultivated in the few years of Karsh's apprenticeship continued after the younger photographer had moved back to Canada. Garo greatly relished their correspondence and relied on this ongoing communication.

Most of their letters maintained the traditional teacher-student relationship, as Garo tried to expand Karsh's vision of photography. Karsh would send Garo pictures for him to critique or inquire about certain color techniques. He questioned what kind of platinum paper was best or asked Garo to send him a particular lens that was hard

to acquire. When Karsh wanted to meet the photographer Edward Steichen so as to understand his methods, Garo arranged a visit for him, and Steichen received the young photographer "in khaki shirt and trousers and bedroom slippers."[146]

Aside from their formal discussions of photography, letters between the two were heartfelt and illustrated their increasing fondness for each other. The connection between Garo and Karsh during this period increasingly changed from a friendly, professional one to something much deeper. Correspondence took on a new tone: one of mutual trust and confidence transcending business. Such was the tone of Karsh's note to Garo in early 1934:

> *I am drafting this letter for you on New Year's Eve among very congenial people with private family in a little farm house a few miles from Ottawa, as I am spending my holidays here in perfect relaxation and peace.*
>
> *For the last three days I have been doing nothing but sleeping, eating and skiing and taking walks towards the mountains which remind me of the week you and I spent in Hillsborough. My walks, of course, lacked your constructive remarks which I absorbed with delight. Oh, how I hope I can reach the stage where I can leave my work for a week or so and be with you or, if I am lucky to have you and Mrs. Garo here sometime, what material for painting.*
>
> *It is truly a gorgeous country. At sunrise you are fascinated by the sway of the trees and shadows they cast on the crystal snow and at night with the moonlight over the valley it seems to be a fairyland as in a dream.*
>
> *The news from my people are not cheerful at all.*

*They are in constant need and I don't feel that it is wise
to bring any of my brothers over unless I am fairly well
established in my business.*

*I had a chat over the telephone with my Uncle last
week. He is contemplating leaving Sherbrooke and
starting in Montreal on account of the illegal competi-
tion in that little town but what a fight he has ahead of
him if he is to start in Montreal.*

*Life is certainly very complicated and erratic and to
overcome it one must pray for patience and persistence.*

*Mr. Garo, I am very, very anxious to receive one of your
letters. A long one that will satisfy my lonely soul for you
and I hereafter promise to write you more often.*[147]

Over time, their writings reflected a closeness that perhaps part-
ing and tough circumstances had accentuated. Garo sent many of his
letters addressed to "My dear Joe" while Karsh termed his friend his
"Master." Eventually their relationship took on familial significance,
with Garo signing his letters "Your Affectionate Dad" and Karsh ad-
vising him to "please remember that you have a son."[148]

Even though he was engrossed in trying to build up his new busi-
ness, Karsh made a few pilgrimages down to Boston to see his paternal
mentor. Karsh proposed that he return to work with Garo at some
point and declared that his time with Garo was unforgettable "be-
cause it is serving as the impetus for everything that I do daily." Garo
wrote, "What is there in life if we cannot be of spiritual as well as
intellectual service to each other?"[149]

Karsh felt a strong bond and even a symbolic debt to Garo. Writing
to him, Karsh related, "I hope that in the next five years I will have
done some creative work that will justify the great schooling and ide-
als you imparted to me when I was with you." Garo encouraged Karsh

and thanked him, admitting, "The depression has been the greatest medium in finding out who your friends are . . ."

Karsh did his best to assist Garo financially, sending him a "gift" from time to time. He even bought railroad tickets for Garo and his wife so they could vacation with him in the Gatineau Hills north of Ottawa. But Garo wrote back:

> I have been trying to figure out some way or other whereby I may be able to give myself the pleasure and joy of being with you for at least two weeks. But so far all prospects are uncertain. I feel like a hen sitting on eggs, expecting every minute or every day something to pop out, which I hope it does as business conditions this year have been at the lowest ebb, for me. I hate to write this sort of letter to you, but feel it is only fair that you should know just how I am fixed. . . .
>
> I do not care whether it is in the country or in the city, or even in Hell—as long as I am with you . . . I shall be perfectly happy. . . . Again I want to tell you it nearly breaks my heart to disappoint you but I can't see any other way out of it.[151]

In September 1935, Garo wrote to Karsh describing "his business as being nil." Karsh wished he could help out more but was just trying to get off the ground himself and had very little extra money. As Garo struggled, so did Karsh, who wrote from Canada that "business here is very bad indeed." When on one of his visits Garo asked him if he could borrow a few hundred dollars, Karsh sadly reported that himself "was in the process of borrowing a hundred and fifty dollars more in order to carry on [his] Ottawa studio."[152]

The following year business in Boston was still stagnant, and Garo

seemed almost despondent. He confessed to Karsh in June of 1936 that "many things are pending. I have never known a time before when I did not know where I was. I cannot get any positive answer from any of those who have things for me to do."[153]

Other friends of Garo's were in even more difficult straits. During the good times, Garo had been a generous soul to many people who came to the studio. Karsh described his view of his mentor's circumstances during this period:

> *Garo attracted friends . . . but perhaps this was because they found in his studio an outlet through which they could express themselves; Garo himself may not have been so close to their hearts. At all events, he enjoyed his friends most when he could persuade them to impose on him, and impose on him they did in the end. They came to his studio, they enjoyed his hospitality. With the stock market crash they came and borrowed his money, and accepted his nitric acid and hypo. Doubtless he suffered financial losses as the result of his own stock speculations . . . but I fear that his speculations on some of his friends must have brought his bitterest setbacks.*[154]

One of the chief debtors was Garo's friend Jack Gibson of New York. And Gibson was in as bad a situation as Garo. Writing to his Boston friend in November 1936, Gibson pleaded:

> *Now please Old Timer, just hold the horses and even though I did vote for Landon, and the other fellow got in, I am in worse position right now than I have been at any time . . . As soon as I can send you a dollar Jack you will have it in the mail.*

But a year later, Gibson wrote to Boston again relating that it was a "worse summer than last" and that his family was "well but broke."[155]

That same year, Garo too was having grave difficulties paying his bills. Due to late payments, the electric company threatened him with a discontinuation-of-service notice, and he was forced to use his photographic work to help pay off some of his debts to the fuel company. Garo was also often behind in rent to his landlord, the patient Mrs. Hackett. Writing to a friend in April 1937, Garo admitted, "I certainly have been through hell the last year or two."[156]

Old acquaintances, including his friends at the Boston City Club, provided a little support to Garo when they could. The club's board commissioned a portrait of one of their past presidents while also agreeing to host a show of Garo's paintings. In December 1937, Garo exhibited another display of his "Famous Gum-Prints" at the club, but the response was limited.[157]

Franklin "Pop" Jordan was another ally who sent checks to Garo to help tide him over. Frank Fraprie also did his best to assist his old Boston Photo-Clan member and coordinated a lighting demonstration class for Garo, writing that the ten-dollar honorarium "will at least buy a drink." He also organized a solicitation of funds from some of Garo's colleagues that totaled around one hundred and forty dollars. Sending the check, Fraprie wrote, "I understand that this is definitely the last amount that can be expected from this source."[158]

Undoubtedly due to his financial situation, Garo became more dependent on alcohol through the 1930s. Once Prohibition ended, Garo kept a full supply of Four Aces whiskey, Novitiate burgundy, and Endicott rum on hand, and although his grand studio parties had ended, his indulgence continued. One family member noted that Garo "really drank a lot" and was often seen around the house sipping a scotch at nine or ten o'clock in the morning. It was due to his drinking that

Garo never applied for a driver's license, instead relying on taxis to shuttle him safely around town.[159]

Garo's jovial nature suffered at times. While friends had once said of him that "he would never get oldish," the pressures of life seemed to hang heavier on him as time went by. When a fellow photographer mentioned to Garo that his showcase window was dirty, Garo volleyed back, "Don't bother me." His situation propelled him to write to Karsh complaining about his family's lack of financial support, but he advised his friend to destroy the letter after reading it. To compound his financial problems, Alice's health was suffering, and during the summer of 1936 Garo began to have "foot trouble," forcing him to close his studio for several weeks at one point.[160]

Garo's family did their best to support him through the tough times. Garo wrote letters to family members asking to borrow money and admitting, "I need help the worst way." John Tomajan led the effort to help his uncle, asking one of his employees to review Garo's financial statements and make recommendations on how to manage the limited income. He also steered a little bit of photo business to Garo whenever he could. Sadly, Garo's plight meant he could rarely visit his family in Worcester, as the twenty-dollar cost of the taxi, he wrote to his sister, was more than he could afford.[161]

In June 1937, Garo conducted an inventory of his studio, including all of his furniture and equipment, to discover what his assets were worth. After a career spanning four decades, he had about two thousand dollars' worth of cameras and lenses but little else worth selling. The Garos had always rented, and owned neither property nor a vehicle of their own. Toward the close of the decade, Garo's state of affairs was bleak, both financially and physically.[162]

Throughout these years of trial and tribulation, Garo's constant light in the darkness was his communication with Karsh, who never forgot to

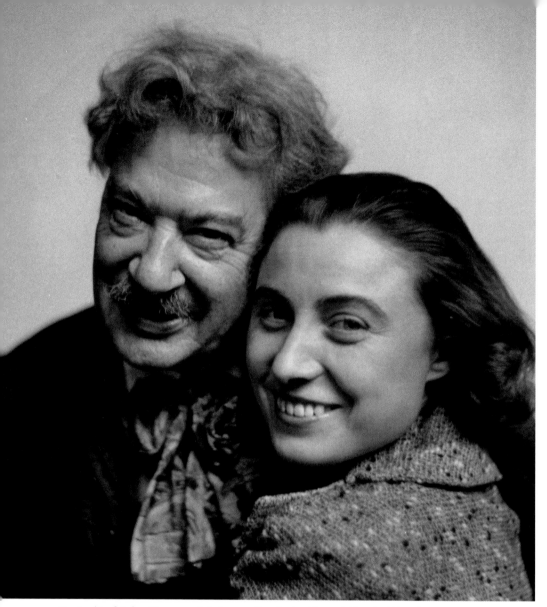

Portrait of John Garo and Solange Karsh, by Yousuf Karsh (1939)

reach out, even when he might have been busy. Karsh understood that despite his mentor's worries, a letter or a note could provide "some pleasure," and Karsh's thoughts were often with Garo even if he could not visit him. In the spring of 1939, Karsh wedded Solange Gauthier, a former actress, who fancifully joked that, "Yousuf is married to his studio. . . . I am only his consort." The very first stop on their honeymoon was a visit to Garo. Karsh described the encounter when they arrived in Boston that May:

Never shall I forget that strange meeting . . . you remem-
ber the Boylston Street Studio—Garo appeared on the
top of the steps while we were away down at the other
end near the fireplace . . . and Garo looked at her long
and searchingly . . . then he spread his arms . . . and I
knew I had chosen right and had his blessings. In no
time they became the greatest of friends.[163]

Garo insisted that he photograph the newly betrothed couple, and Karsh responded by snapping the shutter for a picture of Solange and Garo together, and then proceeded to film the master working in his studio. Karsh and Solange went to the Garos' Jamaica Plain home, which Karsh described as a "shrine," and Alice graciously hosted and played the piano for the guests. Karsh discussed plans to send his brother Malak to study under Garo in Boston that fall. The young couple even disclosed their wish to name their first son after Garo. There was so much to talk about and so little time. After just a brief visit the Karshs were off to enjoy the rest of their vacation, leaving their good friends behind.[164]

Solange and Garo had established a rapport, and she corresponded with him to cheer him up and to thank him for his kind influence on her husband. In words that must have touched Garo, Solange wrote, "You have no idea what a Great God you are in Yousuf's eyes. . . . You most certainly have been his *spiritual* father and, as you know, there is no one in one's life who can ever replace one's spiritual father."[165]

Despite the pressing difficulties of his business, Garo did his best to keep a positive and optimistic outlook. He often signed letters during this time with the admonishment to "cheer up" or "better times are ahead." Staying buoyant was Garo's magic formula. He told a *Boston Herald* reporter that despite his problems he still relished his work, as it was connected to a higher ideal:

I have enjoyed every minute of my life. Photography is my vocation and I love it because I find in it the medium to interpret the art of painting, the art of music, the art of classical literature. But greatest of all, it is my canvas for the fine art of living. Art is everywhere if one can see, hear or feel it. But most of all, it is in life.[166]

Life, however, is fleeting, and even a master of living life, such as Garo, was caught in its mortal grasp. Just a few days after the Karshes left Boston, Garo had a severe heart attack and was admitted to Boston City Hospital. Alice wrote to Karsh worriedly that her husband was "on the danger list!" In early June of 1939 Garo suffered another heart attack, and then an embolism forced the hospital to amputate one of his legs.[167]

Although Karsh wished to pay Garo a visit, he was forever busy with his burgeoning business, trying to establish himself during tough economic times. Karsh had just finished taking portraits of King George VI and Queen Elizabeth on their tour of Canada when he wrote to Alice inquiring about her husband's health. Garo, ever the optimist, never admitted to Karsh the extent of his condition, and Karsh wrote that "he was too proud to tell me how ill he was." Karsh sent money to the couple, and by the end of June, Garo was well enough for the hospital to release him.[168]

But on August 12, Alice wrote to Karsh:

Garo is back in the Boston City Hospital again. And this time his mind is not clear because his heart is in such a condition he does not get enough oxygen to the brain. They think he will get better—but we do not know how long it will take. So the studio will have to be closed and the things stored.

George Bartlett, by John Garo (1914)

Some of Garo's friends pooled their funds and sent the Garos on vacation to New Hampshire. Just as Garo was starting to recuperate, the weather turned very hot and his health began to fail. By early September Garo was in the city hospital again, and Alice wrote, "I can see him losing strength each day."[169]

Garo struggled for several more weeks but his condition only worsened. Then on October 31, 1939, John Garo died. Alice sent Karsh

a personal telegram telling him that his friend had passed away that morning. The "Great Garo" was no more.[170]

Solange traveled to Boston for the funeral service held at the Waterman Chapel on Commonwealth Avenue and the burial at the Forest Hills Cemetery in Jamaica Plain. Karsh was unable to attend, in the midst of a "command sitting" of Canada's governor general John Buchan. Solange comforted Alice and helped her arrange Garo's affairs, working with the lawyers to see what could "be salvaged."[171]

One item she saved was Garo's portrait of the young married couple. Karsh wrote his uncle George Nakash:

> A *few days ago we received a parcel from Boston containing the few negatives Mr. Garo made of Solange and myself. I can assure you that in my entire life I can remember no greater thrill which, at the same time, was combined with a great deal of sorrow. Mr. Garo evidently had retouched them himself but never got the opportunity to print them.*[172]

Despite Solange's help, Alice had "become distracted" and "panicked." She gave away almost everything of value, including a significant collection of Enrico Caruso recordings, to the Salvation Army and to a "long lost relative who suddenly appeared on the scene." There was little left in Garo's estate for her, and when Solange returned to Ottawa she felt "heartbroken" for the widow. It was under these circumstances that Garo's great body of work—his gum arabic negatives and prints, his multichromes, his Garographs, and his great human studies—essentially vanished. Sensing the weight of Alice's loss, Garo's niece Frances Eresian, invited the widow to stay with her family, which Alice occasionally did; it was remembered that "the highlight of her day was a glass of sherry." A little more than a year after Garo's death, Alice passed away in January 1941.[173]

John Higue Garo, a refugee from the Old World, gained a name by rowing "lustily against the stream." He had come from nothing and ascended to the highest heights of artistry and fame, and then his star had fallen in the twilight of his age. But Garo had touched many lives over the years, and the fading star still burned brightly for his family and close friends. When Karsh and Solange heard that Garo had been cremated, they thought "it was only fitting that he who had been such a shining light in life should go out of this world in a shining flame." Although his earthly presence was no longer, his lasting influence as a writer of light would never be extinguished.[174]

Self-portrait, by John Garo

Chapter 6
RESOLUTION

Garo's passing was noted in the Boston papers, as well as other region-
al newspapers and in the Armenian press. Other major outlets took
scant notice. And aside from a 1942 Boston City Club exhibit that
included one of Garo's portraits, there was little else done to com-
memorate him.[175]

Garo's work did not capture any attention in the years following his
death. A new generation of photographers had emerged since Garo's
heyday in the first two decades of the twentieth century. And they,
in turn, were being supplanted by another generation. Society had
changed, and old photographs seemed out of place in modern, post-
war life. Critics considered Garo's portfolio old-fashioned and distant.
American Photography, a longtime supporter of Garo, printed in 1951:
"His pictorial work done with his friends who made up the Boston
Photo-Clan now have little to say to us. His 'Art' does not impress
us."[176]

As time passed, the general ignorance of his accomplishments cast
doubt on Garo's greatness. Skeptics with little knowledge of Garo's

professional standing disparaged his work, like the George Eastman House that found "it a little difficult to believe . . . that Mr. Eastman might have asked Mr. Garo to head Research and Development at the Eastman Company," or the photo curator at the Harvard Art Museum who thought Garo's work was "of no historical value." Some institutions divested his works from their collections, like the Chicago Museum of Science, which sold off one of Garo's exceptional portraits of Edward Everett Hale for a minor sum.[177]

With his death it seemed increasingly likely that John Garo's contribution to the field of photography would be marginalized or perhaps lost from public cognizance altogether. In some ways it was Garo's lack of commercial foresight and marketing strategy that had led to this situation. One observer noted that Garo never made his images available for publication, while another believed that "while he was certainly interested in getting business as a photographer, he was not a promoter . . . [and] was not the go-getter type that Karsh was."[178]

During the 1940s Karsh worked tirelessly to create momentum for his business. After his iconic portrait of Winston Churchill garnered worldwide exposure in 1941, he was sought out for his ability to capture the essence of the individual, and he became one of the leading photographers of the twentieth century. His images of famous women and men further elevated their subjects, transforming "the human face into legend."[179]

In Karsh's mind, his own ability to unhesitatingly seek out celebrated individuals came directly from his time with Garo. As a young assistant Karsh was surrounded by Garo's famous friends: "He would stand at the top of the stairs, ears open, and he listened to them, and he decided these were people he wanted to portray." Karsh himself noted that while these people were eminent figures, he could see privately they were "human beings, as well as artists at the pinnacle of

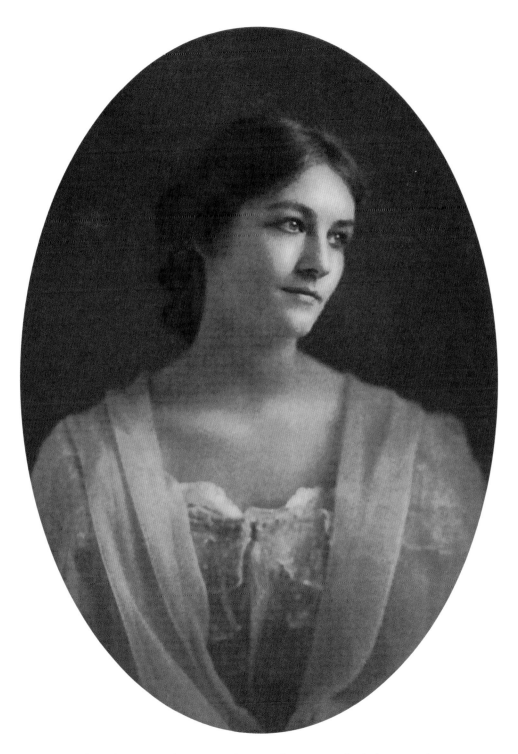

"Portrait," by John Garo, Photo-Era: The American Journal of Photography
(March 1906)

their career—they inspired me, and I hoped I could continue to be in surroundings where I could meet more of such people." Karsh in many ways became Garo's "incarnation."[180]

In another letter to the family, Solange related the couple's deep feelings for their departed friend. She wrote to Garo's niece Frances Eresian:

> There is no doubt that Yousuf has always kept Garo's memory shining bright in his heart and soul . . . he has always acknowledged him and always will, as his Master and spiritual father. What saddens us both is that the great Garo did not live to see his promising pupil turn into the profound and sincere artist which Yousuf has become. No matter what talent Yousuf had to begin with, his stay with Garo gave him not only the necessary photographic knowledge, but the insight into human nature which has carried him to the height he has now reached.[181]

And as Karsh's success grew, so did his feelings of concern for Garo. Karsh fully realized all that his mentor had taught him and wished he had been able to spend more time with Garo. Karsh regretted that he had been unable to assist him further financially and had not been present with Garo at the dusk of his days. In thinking about Garo, Karsh wrote that his master's end "impressed me with a fact that I hold to be a general truth. It is rarely possible to repay those who have conferred great favours on us, who have rendered us great personal kindness. But it is also futile to let one's feelings of remorse for this bear too heavily, to smite one's breast saying that the time for sacrifice, to repay just debts is past, for I do not believe that it ever passes."[182] Replying to a letter from a member of Garo's family, Karsh wrote:

If anything could have brought to me something of Garo's "well-done," your letter has done just that, for your voice was the voice out of a happy past. I have grieved greatly that Garo should not have seen whatever success I have had—for you know and I know how much I owe him. I have always tried to tell the world what Garo has meant to my life.

Clarence Barron, by John Garo (1927)

You are right, he loved me as one of his own and I always have felt and shall always feel often the greatest force in your life is removed before he can gather the fruits of his loving labour.

I know how greatly Garo and Madame Garo suffered in the last few years. I did what little I could but, unfortunately, then I was not in a financial position to do much. It has always been one of my greatest sorrows— again, there I only wish I could have been in a position to do so much more.

I have always felt very sad that apparently, Garo's great negatives have passed on into hands who would never realize their tremendous artistic and human values. Let us only hope that some day by some happy, if unforeseen circumstances, they will be brought to light again.[183]

"The Silver Band," by John Garo (1912)

By 1950, Karsh had begun to think seriously about how to preserve Garo's legacy. To remind himself of his duty, he hung a framed etching of Garo in his studio among other images that were "his especial favourites." One of his first actions was to make a gift to the Photographers' Association of New England in memory of Garo and to organize an event that would serve as a tribute to the deceased artist. In this tribute, John Tomajan recognized the special bond between Garo and Karsh and highlighted the continuity of the relationship, which was ongoing through Karsh's promotion of Garo's creative legacy:

> *It is particularly pleasing to me to have this memorial given by Yousuf Karsh. I have known him from the time when he was in my uncle's studio. One of the things that I have always admired in him is his complete self-lessness and constant gratitude toward my uncle for his contributions to Karsh's knowledge. I know that if my uncle were living, he would protest against receiving any credit, because he would hasten to assure everyone that it is Karsh's innate ability that has carried him to the heights he has reached. That is absolutely true. But I think that Karsh's sentiments bear witness to his real greatness. The temptation is great for a man to become selfish when he becomes successful. Karsh has not done that, and he deserves a great deal of credit for keeping his humility and simplicity throughout his striking career.* [184]

If there was one person determined to ensure that Garo would not be forgotten, it was Yousuf Karsh. Karsh wrote about Garo in his books and frequently discussed him in interviews, never failing to mention how Garo's mentoring had propelled the younger photographer toward his success in photography. And when someone would

Max Fiedler, Music Director,
by John Garo (1908)

begin comparing the two photographers, Karsh would demur; at the proposal that he curate a joint exhibit of his own and Garo's work, he stated that he did not "feel that one should dilute the glory that is Garo with any other artists' work."[185]

In 1951, Karsh began searching in earnest to find Garo's archives. He wrote to the Tomajan family in the hope of locating Garo's cameras and lighting equipment. He focused his efforts especially on what he considered to be Garo's greatest public patrimony—his group of gum arabic negatives and prints. But unfortunately, this portfolio had "mysteriously disappeared."[186]

To Karsh, these works of Garo's were "a tremendous achievement" and "the most permanent portrait medium yet discovered." In a citation recognizing Garo's great works, Yousuf wrote:

> *Where are all these prints at the moment? Alas, they have been dispersed without any records. But I am constantly in search of these glorious prints. I know them all in my mind's eye, as often, in my spare time, as a young apprentice, I would seek inspiration from viewing them. There was always at least one hundred impressive portraits to look at, savour, analyze and [be] thrilled by.*

Karsh hoped to locate the collection in order to place it in a proper repository and to hold an exhibition to highlight the works.[187]

There were rumors of the collection's whereabouts. A contemporary photographer and friend of Garo's, Nazareth Gechijian, believed that the family had sold it to an unknown Jewish businessman. The family, in turn, knew of none of these works except for the few John Tomajan had donated to Harvard University or to the American Antiquarian Society. One researcher believed that a "disgruntled employee" destroyed Garo's portfolio, while others believed the negatives were simply all broken. And one individual thought that the entire collection of negatives was disposed of by Garo himself "so that this 'one of a kind' concept would not allow others to tamper with the idea of making copies."[188]

But Karsh was undeterred and continued his search, frequently corresponding with Garo's family and friends about the missing collection. Along the way he acquired bits and pieces of Garo's work, and he made public statements offering to purchase any of the lost archives that existed. He emphatically queried, "Where, we wonder, are those gems of gum? . . . [prints] which Garo excelled in. The photographic libraries of the world would be enriched by their possession."[189]

By 1955, Karsh had followed the trail of the gum arabics to one of Garo's assistants, Antonio Lombardi. Franklin "Pop" Jordan related to Karsh that Lombardi had seen Garo's negatives in the studio after he had died, and Karsh pursued the suggestion. The former assistant denied knowledge of any prints, but Karsh was unconvinced and wrote, "Lombardi is distressed about having taken them and has so far resisted any efforts to admit that he has them." When three of Garo's photographs materialized, Karsh discovered that they could be traced from a Mr. Wylie to a Mr. Correa to a Mr. Jim Coyne, who happened to be Lombardi's son-in-law. But still Lombardi denied the accusation, and no further works surfaced.[190]

Karsh publicly offered to pay for any of Garo's work that was still in existence: "I'm willing to buy them back if I could find them so that ultimately they would be presented to a museum for all times." He was also quite generous with his own work in order to obtain what he could of Garo's photography. When George Tice, the American photographer, approached him with some Garo photographs and ephemera, Karsh "traded" two valuable prints of Winston Churchill and George Bernard Shaw. Karsh was elated a photograph or landscape painting of Garo's would suddenly materialize and equally dismayed when a hopeful lead resulted in a dead end.[191]

Despite the impossibility of his mission, Karsh refused to give up. An observer said of his quest: "He was relentless. . . . He was absolutely focused. He followed every single lead. There wasn't anything he wouldn't have done." He also encouraged others like Garo's relative and namesake John Garo Eresian to keep at it, urging him "to vigorously pursue your research into the possible whereabouts of the lost Garo treasures." In 1967, Karsh lamented to Eresian that "I was shattered to learn, contrary to my assumption, that John Tomajan was not the one who disposed of them all. I am certain there existed at least one hundred major Gum Arabic prints, for I viewed them myself on numerous occasions. It would be such a tragedy if all these photographic masterpieces were irretrievable."[192]

Eresian and Karsh researched the issue for years, and Karsh admitted that he was "haunted" by the search. By 1974, their investigation came back to the Lombardi family, specifically John Blaker, who had once worked as a photographer for Bachrach Studios of Boston and then married Lombardi's daughter Eleanor. It was believed that Lombardi had originally given thirty of Garo's prints to his son-in-law, and Karsh traced the couple to Houston, Texas. An expressive Karsh wrote to the Blaker family:

"Facade of the Boston Art Museum," by John Garo (1914)

After Garo's death I was saddened to learn that much of
his work was dispersed, which meant that the sum of his
life's accomplishment was fragmented. For many years,
I have been trying to get his work together so that the
rest of the world may see and enjoy his art. I have long
cherished the idea of gathering his prints and present-
ing them to a museum which would treasure them, and
having an exhibition of his work. It would be a great
pity to have his prints locked away where no one could
enjoy them—especially the younger generation of pho-
tographers, who could benefit from his vision.

Unfortunately there was no response.[193]

Karsh even sent a private investigator to search for the Blakers, writing, "I've received no reply and as you will appreciate this is a del-icate matter and if my information is correct it will require subtlety and understanding to extricate them." But the private eye could not locate them, as they had left Houston and their whereabouts were unknown.[194]

In early 1975, John Eresian located the Blakers and wrote to Karsh that they had moved to Shawnee Mission, Kansas. Karsh "dropped everything" and "took a trip to the godforsaken Kansas wheat fields!" He met with the Blakers, and they showed him the works of Garo's that they owned. While there were a few worthwhile pieces, the great archives of the master were still not to be found.[195]

The Blakers sent Karsh a number of items, including prints, some photography journals featuring Garo's work, an advertising piece from the Boylston Street studio, and the bromoil brushes Garo used to treat his gum masterpieces. In return, Karsh sent his portraits of Winston Churchill and Pablo Casals to the Blakers, as well as one of comedi-an Jerry Lewis (with an autograph Karsh had obtained through his connections at the Muscular Dystrophy Association) for the Blakers'

daughter. After Lombardi suffered a stroke in 1984, the family found a few more of Garo's pieces and offered to trade them for five of Karsh's works, which at that time were fetching about a thousand dollars a piece. Karsh placated the family by sending original images of President Dwight Eisenhower, Georgia O'Keeffe, and Norman Rockwell.[196]

Karsh again contacted the Blaker family and thanked them for sharing Garo's work. He noted, however, that the real collection still was missing and stated, "I do believe in miracles and hopefully they will turn up." Karsh also wrote, "I am certain no one would knowingly destroy or harm any of them. They are likely in some dark corner waiting to be recovered."[197]

While it is possible that Garo might have thrown out the negatives himself, it is unlikely. Letters written to customers in his last years of business had stated, "In order to make space for new negatives, it is necessary for us to destroy some of our old ones." But it is more probable that this was a marketing measure to entice customers to purchase their negatives before they were lost "forever." From the correspondence, it does not appear that many of Garo's customers took him up on the offer, and apparently the vast majority of his collection was intact at the time of his death.[198]

While Karsh never discovered the final whereabouts of Garo's full collection, he did work to ensure that Garo would not be forgotten. And although it is the photographs that are his great contribution to perpetuity, something more important than the actual physical artifacts he left behind remains. Garo lived a polychromatic life—through painting and photography and music and intellectual endeavors of all kinds, he sought to enhance the vibrancy of life. His legacy in many ways is his example, through which he taught others that essential existence consists of a combination of artistic inspiration, selflessness, and joie de vivre.

In the spirit of recognizing Garo's contributions to the field, Karsh nominated him to the Professional Photographer's Association Hall of

Fame. Karsh also promoted Garo's legend by perpetuating the generous sharing of knowledge that personified his master. Karsh believed, "We may never be able to pay directly for the gifts of true friendship—but pay we must, even though we make our payment to someone who owes us nothing, in some other place and at some other time." In the last years of his life, Karsh returned to live in Boston, illustrating his commitment to giving back to his old centers of learning; at the Museum of Fine Arts he created an annual lectureship, endowed two photographic curator positions, and established the Karsh Prize for Photography. Students, artists, and professionals continue to benefit from Garo and Karsh's shared belief that an artist is obliged to pass on the light of artistic awareness to others.[199]

Although Karsh passed away in 2002, the Karsh family, led by his widow, Estrellita, has continued to work toward the preservation of Garo's memory. Garo's photographs were featured in *Karsh: A Biography in Images* (published after Karsh's death), while illustrations of his famous gum arabic brushes were prominently featured in displays and promotional materials printed for Ottawa's 2009 Karsh Festival. The Karsh estate encouraged Garo's relatives to donate what remaining works existed (including a sizable collection of Garo's paintings, sketches, and family photographs) to the Library and Archives Canada so that his art would be archived alongside that of his famous apprentice. In death, the two photographers' works in print are now united.[200]

If we are to believe that history progresses forward, that humanity is built upon the foundations of our forerunners, then we need to recognize those who preceded us. Yousuf Karsh received the worldwide recognition his mentor never quite achieved, but he did not forget the debt that was due to his teacher, and it is through Karsh that we understand so much of John Higue Garo's impressive story.

While the work of photography is one of the most personal forms

of preservation, it is obviously not the sole medium for identifying an individual. Garo left behind a tangible legacy for others, not only through a complete archival portfolio of prints and negatives, but through the grand cultural ideas he espoused and shared. His quest to promote art through the eye of the lens is carried on today by tens of thousands of people in a multitude of forms. And through this practice, an appreciation for Garo's contribution to the professional development of Yousuf Karsh, and the field of photography itself, continues to grow. While Garo's final plight is poignant, we can take solace in the fact that he is not forgotten.

"Still life, desk," by John Garo (circa 1920)

NOTES

CHAPTER 1

1. Manoog Dzeron, *Village of Parchanj: General History (1600–1937)* (Fresno, CA: Panorama West Books, 1984), 151; Interview with Dr. Hagop Martin Deranian, September 4, 2009; Peter Balakian, *The Burning Tigris* (New York: HarperCollins Publishers, 2003), 26; Hagop Martin Deranian, *Worcester Is America: The Story of Worcester's Armenians, the Early Years* (Worcester, MA: Bennate Publishing, 1998), 4; Methodist Episcopal Church Missionary Society, *The Gospel in All Lands*, vol. 2, no. 3 (New York: Bible House, 1880), 135.

2. Samuel Totten and Steven Jacobs, eds., *Pioneers of Genocide Studies* (New Brunswick, NJ: Transaction Publishers, 2002), 7; *The Gospel in All Lands*, 135; *Boston Herald*, June 13, 1937, sec. D; Commonwealth of Massachusetts Marriage Register for the City of Worcester, 1895, vol. 453, 584; Yousuf Karsh, *In Search of Greatness* (New York: Knopf, 1962), 21; E-mail from John Garo Eresian, December 9, 2009; *Worcester Telegram*, August 23, 1895, 1; Interview with Archbishop Avak Assadourian, May 15, 2011.

3. Edward Bliss, *Turkey and the Armenian Atrocities* (New York: Edgewood Publishing, 1896), 427; Dzeron, *Village of Parchanj*, 22, 151.

4. Dzeron, *Village of Parchanj*, Parchanj Village Plan, inset; Karsh, *In Search of Greatness*, 21, 22; Letter from Manoog Dzeron to John Garo, April 20, 1937.

5. *Worcester Telegram*, August 23, 1895, 1; *Malden City Directory*, no. XXII (Sampson, Murdock and Co., 1902), 368; Naturalization Record, March 11, 1913, Petition Number 6979; Dzeron, *Village of Parchanj*, 151.

6. *Armenian Mirror-Spectator,* January 7, 1978; Interview with John Garo Eresian, August 13, 2009; Letter from John Garo to Frances Eresian, March 30, 1934; Karsh, *In Search of Greatness,* 22; "Report on Higher Education in the State of New York for the School Year Ending July 31, 1915," *University of the State of New York Bulletin,* no. 671 (September 15, 1918): 103; Armenian Historical Society and Federal Writers' Project, *The Armenians in Massachusetts* (Boston: 1937), 117.

7. Henry Cabot Lodge, ed., *The History of Nations,* vol. XIV (New York: P. F. Collier and Sons, 1913), 498; Balakian, *The Burning Tigris,* 36, 40, 42, 43; Anne M. Avakian, *Armenian Folklore Biography* (Berkeley: University of California Press, 1996), xix; Deranian, *Worcester Is America,* 4.

8. *Armenian Mirror-Spectator,* January 7, 1978; Deranian, *Worcester Is America,* 20, 152, 153; Interview with John Garo Eresian, August 13, 2009.

9. District Court of the United States at Boston, Immigration Petition for John H. Garo, November 15, 1895.

10. Biographical statement about John H. Garo by John Tomajan, n. d.; District Court of the United States at Boston, Immigration Petition for John H. Garo, November 15, 1895; Commonwealth of Massachusetts Marriage Register for the City of Worcester, vol. 453 (1895): 584; *Thirteenth Census of the United States, 1910,* Massachusetts, Suffolk County, Enumeration District 1603, 28A; *Fourteenth Census of the United States, 1920,* Massachusetts, Suffolk County, Enumeration District 384, 9A; *Fifteenth Census of the United States, 1930,* Massachusetts, Suffolk County, Enumeration District 13-641, 4B; *Boston Globe,* November 1, 1939, 17; *Boston Daily Record,* November 1, 1939, 13; *Boston Herald,* November 1, 1939, 23; *Boston Evening Transcript,* November 1, 1939, 20; *San Antonio Express,* November 1, 1939, 3; Interview with Dr. Hagop Martin Deranian, September 4, 2009.

11. *Armenian Reporter,* February 19, 1994; *Armenian Mirror-Spectator,* January 7, 1978; Marc Mamigonian, ed., *The Armenians of New England: Celebrating a Culture and Preserving a Heritage* (Belmont, MA: Armenian Heritage Press, 2004), 194; Interview with Dr. Hagop Martin Deranian, September 4, 2009; Guide to the Photograph Collection, Alice Bache Gould Photographs, Photograph Collection 166, Massachusetts Historical Society.

12. Armenian Historical Society and Federal Writers' Project, *The Armenians in Massachusetts,* 117; Deranian, *Worcester Is America,* 43.

13. Armenian Historical Society and Federal Writers' Project, *The Armenians in Massachusetts,* 117; *Boston Herald,* June 13, 1937, sec. D.

14. *Worcester Telegram and Gazette,* December 21, 2001; *Worcester City Directory* (Drew, Allis, 1889); *Boston Herald,* June 13, 1937, sec. D.

15. William F. Robinson, *A Certain Slant of Light: The First Hundred Years of New England Photography* (Boston: New York Graphic Society, 1980), 181; Karsh, *In Search of Greatness,* 22; Armenian Historical Society and Federal Writers' Project, *The Armenians in Massachusetts,* 117.

16. Armenian Historical Society and Federal Writers' Project, *The Armenians in Massachusetts*, 117, 29; Franklin P. Rice, *Dictionary of Worcester and Its Vicinity* (Worcester: F. S. Blanchard, 1893), 84; "Part 1 of Examinations by the State Board of Health of the Water Supplies and Inland Waters of Massachusetts, 1887–1890" (Massachusetts Department of Public Health, 1890), 29.

17. Interview with John Garo Eresian, August 13, 2009; *Worcester City Directory*, 1889 and 1890.

CHAPTER 2

18. *Revere City Directory*, 1892, 584; *Boston City Directory*, 1890, 515; *Boston City Directory*, 1891, 524; *Boston City Directory*, 1892, 539; *Boston City Directory*, 1893, 544; *Boston City Directory*, 1894, 550; *Boston City Directory*, 1895, 571; *Boston City Directory*, 1896, 610; *Boston City Directory*, 1897, 611; *Boston City Directory*, 1898, 617; *Boston City Directory*, 1899, 618.

19. *Boston City Directory*, 1891, 524; *Boston: Its Finance, Commerce and Literature* (Boston: A. F. Parsons, 1892), 257.

20. Mamigonian, *The Armenians of New England*, 194; *Boston Herald*, June 13, 1937, sec. D; Collections of Joan Gold, Bruce Papazian, and John and Van Eresian.

21. John H. Garo, Bryan Davagian, *Armenian Mirror-Spectator*, March 5, 1994, 10; Collections of Library and Archives Canada, Armenian Library and Museum of America, Marylyn Tomajan, and John and Van Eresian.

22. E-mail from John Curuby, Boston Art Club, August 17, 2009; Nancy Allyn Jarzombek, *A Taste for High Art: Boston and the Boston Art Club, 1855–1950* (Boston: Vose Galleries, 2000), 12; Laura Meister, Report on John H. Garo for Lucy der Manuelian, January 16, 1997.

23. *Boston Herald*, June 13, 1937, sec. D; *Worcester Telegram*, August 23, 1895, 1; Karsh, *In Search of Greatness*, 28; Interview with John Garo Eresian, August 13, 2009.

24. Deranian, *Worcester Is America*, 171; *Worcester Telegram*, August 23, 1895, 1.

25. *Worcester Evening Gazette*, August 23, 1895, 5; *Worcester Telegram*, August 23, 1895, 1.

26. *Boston City Directory*, 1914, 782; *Boston Herald*, June 13, 1937, sec. D.

27. American Board of Commissioners for Foreign Missions, *Missionary Herald* XCIX, no. 1 (Boston: Beacon Press, January 1903): 10; Bliss, *Turkey and the Armenian Atrocities*, 439.

28. Balakian, *The Burning Tigris*, 87, 110; Interview with John Garo Eresian, August 13, 2009; *Boston Herald*, June 13, 1937, sec. D.

29. Interview with Dr. Hagop Martin Deranian, September 4, 2009; Interview with John Garo Eresian, August 13, 2009.

30. *Boston City Directory*, 1891, 524; *Boston City Directory*, 1894, 550; *Boston City Directory*, 1896, 610; *Boston City Directory*, 1897, 611.

31. *Boston City Directory*, 1897, 611; Collection of Van and John Garo Eresian; Interview notes with Peter Zakarian, July 24, 1989; *Wellesley* magazine 7, no. 7 (April 1899): 518; *Folio* XXV, no. 6 (June 1884): 244; *Boston City Directory*, 1898, 617; *Illustrated Boston: The Metropolis of New England* (New York: American Publishing and Engraving, 1889), 150.

32. Carol McCusker and Mark Berndt, "The Digital Age: Color Fully Realized," *Color*, no. 3 (September 2009); A. J. Philpott, (September 2009); A. J. Philpott, "Garo of Boston," *American Photography* (August 1912): 434.

33. P. K. Thomajan, "Portrait of John Garo," *Ararat* (Autumn 1964): 37; *Wilson's Photographic Magazine* XLII, no. 586 (October 1905): 451, 452; *Photographic Times* XXXIII, no. 12 (December 1901): 580; *Photographic Times* XXXIV, no. 1 (January 1902): 23.

34. Thomajan, "Portrait of John Garo," 40.

35. *Photo-Era: The American Journal of Photography* XXIX, no. 1 (July 1912): 23, 44; John Hannavy, ed., *Encyclopedia of 19th Century Photography*, vol. 1 (London: Routledge, 2007), 306.

36. Interview with John Garo Eresian, August 13, 2009; Tomajan and Eresian Family History, John Garo Eresian; *Boston Journal*, August 23, 1906, 12; *Bulletin of Photography* XIV, no. 356 (June 3, 1914): 675, 676; *Photo-Era* XXXIV, no. 1 (January 1915): 30.

37. *Photo-Era* XXVIII, no. 5 (May 1912): 184; *Wilson's Photographic* XXXVIII, no. 532 (April 1901): 130, 131; *Photo-Era* VII (February 1902): 316.

38. *Wilson's Photographic* XLII, no. 587 (November 1905): 498, 499.

39. *Wilson's Photographic* XXXVIII, no. 538 (October 1901): 397; Trustees of the Museum of Fine Arts, Twenty-Sixth Annual Report, for the year ending December 31, 1901 (Boston: Alfred Mudge and Son, Printers, 1902), 11, 129; *National ??????? Magazine* XV, no. 2 (November 1901): 202, 205; *Camera* VII, no. 9 (September 1903): 333; *Photographic Times* XXXIII, no. 12 (December 1901): 557; *Photographic Times* XXXIII, no. 8 (August 1901): 351, 355; *Photographic Times* XXXIV, no. 1 (January 1902): 23; *Photographic Times* XXXV, no. 1 (January 1903): frontispiece; *Zion's Herald*, June 3, 1903.

40. *Hairenik*, November 3, 1939, 1; Thomajan, "Portrait of John Garo," 39; *Boston Globe*, June 23, 1902, 4; Exhibition of Portraits and Landscapes by John H. Garo, Boston Art Club, 1916; *Boston City Directory*, 1902, 2426; Karsh, *In Search of Greatness*, 23.

41. Boston Landmarks Commission Building Information Form for 733–739 Boylston Street, 1984; *Architectural Record* XIX, no. 4 (April 1906): 314; *American Architect and Building News* 80, no. 1453 (June 27, 1903): 110.

42. *Second Annual Catalogue of Simmons College* Boston, 1903–1904 (Boston: Simmons College, 1904), 12; *Handbook of the Museum of Fine Arts, Boston*, 1908, 304; *School Arts Book* IV, no. 6 (February 1905): 384; *Boston Daily Globe*, March 17, 1905, 5; *Patterson's College and School Directory of the United States and Canada* (Chicago: American Educational Co., 1905), 97; Florence Levy, ed., *American Art Annual*, vol. VI (New York: American Art Annual Inc., 1908), 395; Florence Levy, ed., *American Art Annual 1905–1906*, vol. V (New York: American Art Annual Inc., 1905), 508; School Arts Book IV, no. 6 (February 1905): 384; *Outlook for the Blind*, Massachusetts Association for Promoting the Interests of the Blind, vol. III, no. 4 (Winter 1910): 203; *Smith College Monthly* 21 (1913): 187.

43. *Photo-Era* XLVII, no. 1 (July 1921): 103; *Photo-Era* XXXII, no. 5 (May 1914): 256.

44. Karsh, *In Search of Greatness*, 23, 31; Thomajan, "Portrait of John Garo," 40.

45. Garo Studios inventory list dated June 9, 1937; Karsh, *In Search of Greatness*, 24; Sidney Allan, "John H. Garo: An Appreciation," *Camera* IXX, no. 4 (April 1915): 196; *Boston Herald*, June 13, 1937, sec. D; Photograph "A Corner of the Garo Studio Boston Mass" from the Eresian collection.

46. Garo Studios advertisement, "The Importance of Appointments," n. d.; Karsh, *In Search of Greatness*, 24.

47. Karsh, *In Search of Greatness*, 36; Interview with John Garo Eresian, August 13, 2009; Thomajan, "Portrait of John Garo," 38; Jay Robert Nash, *The Innovators* (Chicago: Regnery Gateway, 1982), 67.

48. Interview with John Garo Eresian, August 13, 2009; Karsh, *In Search of Greatness*, 17; Ruth Thomasian, *Armenian Photographers of New England* (draft), April 16, 2001; Portrait of John H. Garo by Yousuf Karsh, Museum of Fine Arts collection; Interview notes with Peter Zakarian, July 24, 1989; Thomajan, "Portrait of John Garo," 38; *Boston Traveler*, May 1915.

49. Karsh, *In Search of Greatness*, 24, 31; Interview with John Garo Eresian, August 13, 2009.

50. Arshag Mahdesian, "Armenia: Her Culture and Aspirations," *Journal of Race Development*, Clark University, vol. 7, no. 4 (April 1917): 460; *Photo-Era* X, no. 5 (May 1903): 160.

51. Philpott, "Garo of Boston," 432, 434.

52. Sadakichi Hartmann, *The Valiant Knights of Daguerre* (Berkeley: University of California Press, 1978), 221.

CHAPTER 3

53. Garo Studios advertisement, "The Importance of Appointments," n. d.

54. Letter to Henry Jones from John Garo, n. d.

55. *Boston City Directory*, 1906, 744; *Photo-Era* 17, (July–December 1906): 52; *Abel's Photographic Weekly* XIV, no. 340 (July 4, 1914): 10; M. F. Sweetser, *All Along Shore* (Boston: Boston and Maine Railroad Passenger Department, 1889), 44; *Photographic Times* XXXVIII, no. 6 (June 1906): 267.

56. *Wilson's Photographic* XLIII, no. 597 (September 1906): 434, 435; "An Act to Amend and Consolidate the Acts Representing Copyright," sec. 18, 1909; William Benjamin Hale, A *Treatise on the Law of Copyright and Literary Property*, 1031.

57. *Boston Globe*, May 28, 1905, 7.

58. *Boston Globe*, May 28, 1905, 7; Meaghan Dwyer-Ryan, Susan L. Porter, and Lisa Fagin Davis, *Becoming American Jews: Temple Israel of Boston* (Lebanon, NH: University Press of New England, 2009), 41.

59. *Edward Curtis: The Master Prints*, Peabody Essex Museum (Santa Fe, NM: Arena, 2001), 11; Barbara A. Davis, *Edward S. Curtis: The Life and Times of a Shadow Catcher* (San Francisco: Chronicle Books, 1985), 46; Ralph Andrews, *Curtis' Western Indians* (New York: Bonanza Books, 1962), 35, 37.

60. *Boston Daily Globe*, January 8, 1913, 2; and January 10; and January 12, 1908, 8; and May 5, 1925, 10; Sherrill V. Martin, *Henry F. Gilbert: A Bio-bibliography* (Westport, CT: Praeger Publishers, 2004), 49, 59; January 12, 1908, 8; May 5, 1925, A18; Letter to Mrs. Richard H. Jones from John Garo, November 2, 1936.

61. Phyllis Méras, *The Historic Shops and Restaurants of Boston* (New York: Little Bookroom, 2007), 208; *Boston Daily Globe*, August 8, 1915, 41; *Boston Daily Globe*, May 16, 1911, 9; John Garo Eresian interview with John Blaker, July 8, 2000; *St. Petersburg Evening Independent*, February 14, 1964, 6-A; *Bulletin of Photography* XIX, no. 471 (August 16, 1916): 239.

62. *Photo American* XVII (January-December 1906): 399; *Photo-Era* 31 (1913): 168; *Photo-Era* XXXVII, no. 3 (September 1916): 147; *Bulletin of Photography* XIV, no. 357 (June 10, 1914): 721; *Bulletin of Photography* XV, no. 360 (July 1, 1914): 20; *Photographic Review* 26, no. 1 (January 1920): 14; *American Photography* II, no. 10 (October 1908): 579; *New York Times*, April 22, 1923, X7; *American Photography* XV (January 1921): 46; *Wilson's Photographic* XLVIII, no. 660 (December 1911): 544; Letter from Carrie S. Allen to John Garo, November 16, 1937; *American Photography* III, no. 2 (February 1909): 117; *Photo-Era* XL, no. 4 (April 1918): 220.

63. *Photographic Times*, September 1906, 432; *Boston Journal*, August 24, 1906, 3; *Boston Herald*, June 13, 1937, sec. D; *Christian Science Monitor*, October 15, 1914, 4; *American Photography* III, no. 11 (November 1909): 678; *Camera* 11 (1907): 358; *Wilson's Photographic* XLIV, no. 610 (October 1907): 436; *Photographic Journal of America* LVII, no. 12 (December 1920): 476; *American Amateur Photographer* XVIII, no. 10 (October 1906): 501; *Photographic Times-Bulletin* XXXVI, no. 4 (April 1904): 185; *New Armenia*, vol. 5 (New York: New Armenia Publishing, 1911), 356; *Photo-Miniature* IX, no. 101 (October 1909): 238; *American Photography* III, no. 11 (November 1909): 678.

64. Hartmann, *The Valiant Knights of Daguerre*, 5; *Camera Work*, October 1909, 33, 36.

65. Letter to Alfred Stieglitz from John H. Garo, July 5, 1911.

66. *Wilson's Photographic* XLVIII, no. 658 (October 1911): 437.

67. Letter from John Garo to Alfred Stieglitz, March 4, 1912; Letter from Alfred Stieglitz to John Garo, March 5, 1912.

68. *Boston Daily Globe*, July 29, 1910, 2; *Wilson's Photographic* XLVIII, no. 658 (October 1911): 433; *Wilson's Photographic* XLV, no. 621 (September 1908): 387.

69. *American Photography* IV, no. 9 (September 1910): 546.

70. *American Photography* IV, no. 9 (September 1910): 546; *Abel's Photographic Weekly* IX, no. 215 (February 1912): 643; *Yearbook of the Photographers' Association of New England*, 1914; *Wilson's Photographic* XLVII, no. 645 (September 1910): 386–399; *Wilson's Photographic* XLVIII, no. 655 (July 1911): 336; *Wilson's Photographic* XLVIII, no. 656 (August 1911): 338.

71. *Wilson's Photographic* XLVIII, no. 656 (August 1911): 340; *Wilson's Photographic* XLVIII, no. 658 (October 1911): 433, 436.

72. *American Photography* (New York: Camera Club of New York, Boston Photo-Clan, Photo-Pictorialists of Buffalo Society), vol. 7, no. 9 (September 1913): 500.

73. *American Photo-Era* (New York: Camera Club of New York, Boston Photo-Clan, Photo-Pictorialists of Buffalo Society), vol. 7, no. 9 (September 1913): 500, 502, 504; Photo-Era XXXIV, no. 4 (April 1915): 203; William Anthony Sheppard, *Revealing Masks: Exotic Influences and Ritualized Performance in Modernist Music Theater* (Berkeley: University of California Press, 2001), 171; *Image: Journal of Photography of the George Eastman House* 1, no. 2 (February 1952): 3; *Photo-Era* XLVIII, no. 5 (May 1922): 287; Wilmon Brewer, *A Life of Maurice Parker* (Francestown, NH: Marshall Jones, 1954), 14, 15, 20, 21, 34.

74. *American Photography*, (New York: Camera Club of New York, Boston Photo-Clan, Photo-Pictorialists of Buffalo Society), vol. 7, (February 1913): 122, 123; *American Photography*, (New York: Camera Club of New York, Boston Photo-Clan, Photo-Pictorialists of Buffalo Society), vol. 7, no. 9 (September 1913): 504; *American Photography* By Camera Club of New York, Boston Photo-Clan, Photo-Pictorialists of Buffalo (Society), vol. 7, no. 9 (September 1913): 502.

75. *Christian Science Monitor*, August 30, 1911, 16; J. B. Schriever, *Photographic Printing Part I*, vol. IV of *Complete Self-Instructing Library of Practical Photography* (Scranton, PA: American School of Art and Photography, 1909), 385.

76. *Wilson's Photographic* XLV, no. 613 (January 1908): 1; *Clark's Boston Blue Book* (Boston: Sampson and Murdock, 1908), 5; Thomajan, "Portrait of John Garo," 39; *American Photography* II, no. 1 (January 1908): 38.

77. *American Photography* II (1908): 2; "Head and Shoulders Profile of a Woman," Garo #14, Garo #15, Museum of Fine Arts Boston John Garo Collection, L-R 174.1998; Allan, "John H. Garo: An Appreciation," 196; *Christian Science Monitor*, November 3, 1923, 4; Letter from Pirie MacDonald to John Garo, April 10, 1912, in *The New Art* (Garo Studios, 1912), 6.

78. *The Multichrome: A New Process in Color Photography* (Garo Studios, 1912), 3.

79. Letter from A. J. Philpott to John Garo, March 5, 1912; Letter from Chase Emerson to John Garo, March 22, 1912; Letter from Pirie MacDonald to John Garo, April 10, 1912.

80. Biographical statement on John H. Garo by John Tomajan, n. d.; Thomajan, "Portrait of John Garo," 39.

81. Biographical statement on John H. Garo by John Tomajan, n. d.; Thomajan, "Portrait of John Garo," 39; Karsh, *In Search of Greatness*, 31; Nash, *The Innovators*, 67; John H. Garo biographical piece (Yousuf Karsh Collection, Library and Archives Canada); Letter from Franklin "Pop" Jordan to Yousuf Karsh, May 2, 1951.

82. *Christian Science Monitor*, May 16, 1914, 13; *American Photography* (New York: Camera Club of New York, Boston Photo-Clan, Photo-Pictorialists of Buffalo Society), vol. 7, no. 9 (September 1913): 500.

83. *Photo-Era* XXIX, no. 9 (September 1912): 143; *Photo-Era* XXXII, no. 198 (1914): 198; Letter to Robert Brett from Ada K. Greenberg, January 31, 1965.

84. Philpott, "Garo of Boston," 432.

85. Andrew H. Eskind, ed., *International Photography: George Eastman House Index to Photographers, Collections and Exhibitions* (New York: G. K. Hall, 1998), 214; Letters from John Garo to Alfred Stieglitz, July 29, 1912, and August 8, 1912.

86. Letter from John Garo to Alfred Stieglitz, August 8, 1912.

87. *Photo-Era* XXV, no. 1 (July 1910): 2; *Armenian Reporter*, February 19, 1994, 8; Hartmann, *The Valiant Knights of Daguerre*, 224; Thomajan, "Portrait of John Garo," 36; Library of Congress John Garo Collection; Fogg Art Museum, Harvard University; Letter to Franklin D. Roosevelt Jr. from Garo Studios, May 10, 1937; Letter to Channing H. Cox from John Garo, February 5, 1937; *Photo-Era* XXXVII, no. 6 (December 1916): 297; *New York Times*, July 23, 2007; Fundación Juan Ramón Jiménez Collection; *Century Magazine* LXXX, no. 4 (August 1910): 546; *New York Times*, January 4, 1931; *Boston Globe*, November 19, 1910; *Boston Transcript*, November 8, 1923, and October 23, 1916; Boston Art Club John H. Garo Exhibition List, October 1916; *Photo-Era* XVIII, no. 1 (January, 1907): 49; Nash, *The Innovators*, 67.

88. *Wilson's Photographic* LI, no. 658 (November 1914): 503; *Boston Daily Globe*, May 15, 1914; *Boston Transcript*, May 11, 1914; *Boston Daily Globe*, October 23, 1916.

89. *Photo-Era* XXXVII, no. 6 (December 1916): 297; *Photo-Era* XXXIV, no. 1 (January 1915): 30.

90. Letter to Charles J. Adams from John Garo, October 17, 1935; Interview with John Garo Eresian, August 13, 2009; Letter from unknown to John Garo, n. d.; Letter from Irving G. Findlay to John Garo, June 14, 1938; Letter from Leslie D. Martin to John Garo, June 1, 1938; Tomajan and Eresian Family History, John Garo Eresian.

91. *Abel's Photographic Weekly* XIV, no. 357 (October 31, 1914): 427.

92. *Photo-Era* 31 (1913): 297; Philpott, "Garo of Boston," 432, 434; *Boston Transcript*, May 11, 1914; *Boston Daily Globe*, May 15, 1914; *Boston Transcript*, October 23, 1916; *Boston Daily Globe*, October 23, 1916; *Wilson's Photographic* XLV, no. 623 (November 1908): 482.

93. Hartmann, *The Valiant Knights of Daguerre*, 1, 4, Allan, "John H. Garo: An Appreciation," 195, 196, 199.

94. Habet M. Filipposean, Hishatakaran Eprat Golechi, Hratarakutiwn Eprat Golechi Sanuts Miutean, *Memoranda of Euphrates College* [formerly Armenia College] 1878–1915 (Boston: 1942).

95. *Photo-Era* LII, no. 2 (February 1924): 106; *Boston Transcript*, November 8, 1923; Thomajan, "Portrait of John Garo," 40; *Boston Evening Transcript*, November 1, 1939, 20; Karsh, *In Search of Greatness*, 24; *Photo-Era* LII, no. 3 (March 1924): 172.

Chapter 4

96. *Boston Evening Transcript*, n. d.

97. John Garo, "Our Bridgeport Meeting and What It Means," *Yearbook of the Photographers' Association of New England* (1914).

98. *American Photography* XV, no. 8 (August 1921): 467; Allan, "John H. Garo: An Appreciation," 196; *Christian Science Monitor*, November 3, 1923, 4.

99. *Boston Traveler*, May 1915; *Boston Herald*, June 13, 1937, sec. D; *Photographic Journal of America* LVII, no. 12 (December 1920): 476; Interview with Estrellita Karsh, May 30, 2010; George Waldo Browne, *The History of Hillsborough, New Hampshire*, vol. II (Manchester, NH: 1922), 399; E-mail from Gilman Shattuck, Hillsborough, New Hampshire, Historical Society, September 7, 2009.

100. Allan, "John H. Garo: An Appreciation," 196; Philpott, "Garo of Boston," 434; *American Photography* XXIII, no. 12 (December 1929): 654.

101. *American Photography* XXIII, no. 12 (December 1929): 660.

102. Interview with Estrellita Karsh, May 30, 2010; *Boston Daily Globe*, September 30, 1926, A14; *American Photography* XXIII, no. 12 (December 1929): 654; John H. Garo sketchbook, Karsh Collection, Library and Archives Canada.

103. M. A. DeWolfe Howe, *The Boston Symphony Orchestra: An Historical Sketch* (Boston: Atlantic Monthly Press, 1914), 204, 218; John Ogasapian and Lee Orr, *Music of the Gilded Age* (Westport, CT: Greenwood Publishing Group, 2007), 27.

104. *Baltimore Sun*, November 6, 1924, 12; X11; *Washington Post*, May 25, 1924, A3; *New York Times*, February 17, 1924, X11; *Bulletin of Photography* XXVI (January 7–June 30, 1920): 108.

105. Pictorial Photographers of America, *Pictorial Photography in America* (New York: Tennant and Ward, 1920), xxii.

106. *American Photography*, (New York: Camera Club of New York, Boston Photo-Clan, Photo-Pictorialists of Buffalo Society), vol. 21 (1927): 663; Guide to the Henry Eichheim Papers, 1900–1930s, University of California Santa Barbara, 2003, 3; Interview with John Garo Eresian, August 13, 2009; *Harvard Crimson*, April 25, 1949.

107. *American Photographer* XIX, no. 6 (June 1925): 369.

108. *Fourteenth Census of the U.S.*, 1920, Brookline, Norfolk, T625-721, Enumeration District 164, 12A.

109. *Himmat* XII (1975): 18; Yousuf Karsh and David Travis, *Regarding Heroes* (Boston: David R. Godine, 2009), 12; Nash, *The Innovators*, 65–67; Maria Tippett, *Portrait in Light and Shadow: The Life of Yousuf Karsh* (New Haven, CT: Yale University Press, 2007), 34; Karsh, *In Search of Greatness*, 21; Fergus Greer, *Portraits: The World's Top Photographers* (Mies, Switzerland: RotoVision SA, 2006), 82.

110. Karsh, *In Search of Greatness*, 22, 25, 32, 33.

111. Letter to Yousuf Karsh from Franklin "Pop" Jordan, (Yousuf Karsh Collection, Library and Archives Canada) October 30, 1954, R613 Volume 52, Folder 20.

112. Yousuf Karsh, *Karsh: A Fifty-Year Retrospective* (Toronto, Ontario, Canada: University of Toronto Press, 1983), 9; Karsh, *In Search of Greatness*, 25, 27, 33, 34.

113. *Abel's Photographic Weekly* XIII, no. 318 (January 1914): 113; Letter from John Garo to A. J. Philpott, February 6, 1936.

114. Karsh, *In Search of Greatness*, 25, 26.

115. *Boston Globe*, October 28, 1975; Interview with Estrellita Karsh, January 10, 2012; Karsh, *Karsh: A Fifty-Year Retrospective*, 9; *Seventy-First Annual Report of the Trustees of the Public Library of the City of Boston*, 1922–1923 (Boston: Trustees of the Library, 1923), 36; Karsh, *In Search of Greatness*, 32, 33.

116. Karsh, *In Search of Greatness*, 33; Karsh, *Karsh: A Fifty-Year Retrospective*, 9; Devon Francis, "How Karsh Pictures Celebrities," *Popular Science* (October 1952): 222.

117. John H. Garo citation by Yousuf Karsh, n.d., 1; Karsh, *In Search of Greatness*, 31, 32.

118. Karsh, *In Search of Greatness*, 31, 35.

119. Karsh, *Karsh: A Fifty-Year Retrospective*, 9.

120. Karsh, *Karsh: A Fifty-Year Retrospective*, 9; Karsh, *In Search of Greatness*, 35; *Photo-Miniature* XVI (December 1921): 184; John Garo, "The Possibilities of Photography," *American Photography* XXIII, no. 12 (December 1929): 658.

121. Karsh, *In Search of Greatness*, 32.

122. John H. Garo citation by Yousuf Karsh, n. d., 2; Francis, "How Karsh Pictures Celebrities," 222.

123. Thomajan, "Portrait of John Garo," 38; Karsh, *In Search of Greatness*, 27, 30; James Danziger and Barnaby Conrad III, *Interviews with Master Photographers* (New York: Paddington Press, 1977), 101.

124. Karsh, *In Search of Greatness*, 28; Thomajan, "Portrait of John Garo," 38.

125. Tomajan and Eresian Family History, John Garo Eresian; John H. Garo citation by Yousuf Karsh, n. d., 2; Danziger and Conrad, *Interviews with Master Photographers*, 110; Karsh, *In Search of Greatness*, 30.

126. Karsh, *In Search of Greatness*, 29.

127. Nash, *The Innovators*, 67; Danziger and Conrad, *Interviews with Master Photographers*, 110; Interview with Estrellita Karsh, January 10, 2012; Karsh, *Karsh: A Fifty-Year Retrospective*, 9.

128. Karsh, *In Search of Greatness*, 34.

129. Ibid.

130. Karsh, *In Search of Greatness*, 37; Nash, *The Innovators*, 69.

131. *Wilson's Photographic* XLVIII, no. 658 (October 1911): 436.

132. Karsh, *In Search of Greatness*, 34.

133. Festival Karsh Ottawa exhibit brochure (2009), 7; Letter from John Garo to Yousuf Karsh, (Yousuf Karsh Collection, Library and Archives Canada) March 10, 1930, R613 Volume 3, Folder 19.

CHAPTER 5

134. *Wilson's Photographic* XLVIII, no. 658 (October 1911): 436; Thomasian, *Armenian Photographers of New England* (draft); Ruth Thomasian, "Armenian Photographers of New England," in Mamigonian, Marc, *The Armenians of New England* (Belmont, MA: Armenian Heritage Press, 2004) 195; Herbert Kenney and Damon Reed, *New England in Focus: The Arthur Griffin Story* (Winchester, MA: Arthur Griffin Center for Photographic Art, 1995), 1; Kitty Parsons Recchia, ed., *Artists of the Rockport Art Association (1940)*.

135. Garo, "The Possibilities of Photography," 656.

136. Letter to Paul True from John Garo, November 18, 1935; Letter from Arthur D. Little to Blair M. Smith, January 4, 1935; Letter to Dana Sylvester from Garo Studios, March 3, 1936.

137. Letter to E. W. Thomson from John Garo, October 19, 1935; *Wilson's Photographic* XLVIII, no. 658 (October 1911): 436.

138. *Wilson's Photographic* XLIII, no. 593 (May 1906): 202; Letter to Mrs. A. W. Peggio from John Garo, April 14, 1936.

139. *Boot and Shoe Recorder* LXXIX, no. 14 (June 25, 1921): 66; Letter from John Garo to W. L. Gladding, June 21, 1935.

140. Letter to M. J. Bonwit from Garo Studios, March 25, 1937; Letter from A. Humes to John Garo, October 9, 1936; Letter from J. Carrol Brown to John Garo, February 13, 1938; Letter from William Havican to John Garo, June 27, 1936.

141. Letter to Mrs. G. H. Mifflin from John Garo, July 11, 1935; Letter to C. L. Bond from John Garo, January 17, 1930; Letter to R. P. Snelling from John Garo, July 11, 1935; Letter from Dwight Blaney to John Garo, December 5, 1936.

142. Letter to Lester Hornby from John Garo, July 23, 1936; Letter to Mrs. David R. Pokross from Garo Studios, March 25, 1937; Letter to Richardson, Alley and Richards from Garo Studios, May 15, 1935; *American Photography* 30 (1936): 408; Letter to Amy M. Sacker from Garo Studios, January 23, 1935; Letter from Garo Studios sent to unknown clients, December 7, 1934; Letter to A. J. Philpott from John Garo, October 19, 1936; Letter from Mildred G. Bradbury to John Garo, March 12, 1936; Letter from Charles J. Adams to John Garo, March 9, 1935; Letter to Theodore Roberts from John Garo, March 13, 1936; Letter from Mildred Beal to John Garo, April 14, 1938.

143. Garo Studios New Year's Letter list, January 1936; *Photo-Era* LII, no. 3 (March 1924): 166; *Boston Daily Globe*, March 15, 1923, 12; Letter to Laurence Morgan from John Garo, April 1, 1936; Letter from John Garo to Frances Eresian, n. d.

144. Letter from John Garo to Howard Beech, August 23, 1935.

145. Letters from Frank R. Fraprie to John Garo, March 6, 1935, and April 2, 1935; Letter from Board of Governors of the Boston Art Club to John Garo, February 20, 1937; Letter from Leslie D. Martin to John Garo, June 1, 1938.

146. Letters from Yousuf Karsh to John Garo, February 2, 1937, and March 29, 1938; Letter from John Garo to Yousuf Karsh, April 12, 1930; Letters from Yousuf Karsh to John Garo, July 13, 1933, and June 2, 1936.

147. Letter from Yousuf Karsh to John Garo, January 3, 1934.

148. Letters from John Garo to Yousuf Karsh, April 12, 1930; October 16, 1931; and July 22, 1933; Letters from Yousuf Karsh to John Garo, March 29, 1938, and October 9, 1936; Letter from John Garo to Yousuf Karsh, December 13, 1938; Letter from Yousuf Karsh to John Garo, July 29, 1936.

149. Letter from Yousuf Karsh to John Garo, May 5, 1933; Letter from John Garo to Yousuf Karsh, April 22, 1936; Letters from Yousuf Karsh to John Garo, March 29, 1938, and September 24, 1935; Letter from John Garo to Yousuf Karsh, October 14, 1936.

150. Letter from Yousuf Karsh to John Garo, November 14, 1938; Letter from John Garo to Yousuf Karsh, February 12, 1937.

151. Letter from John Garo to Yousuf Karsh, June 5, 1937; Letter from Yousuf Karsh to John Garo, June 2, 1936; Letter from John Garo to Yousuf and Solange Karsh, July 17, 1936.

152. Letter from Yousuf Karsh to A. George Nakash, September 28, 1935; Letter from Yousuf Karsh to John Garo, March 29, 1938; Karsh, *In Search of Greatness*, 38.

153. Letter from John Garo to Yousuf Karsh, June 29, 1936.

154. Karsh, *In Search of Greatness*, 37.

155. Letter from Jack Gibson to John Garo, November 27, 1936; Letter from Jack Gibson to Doris A. Genne, August 2, 1937.

156. Letter from the Boston Edison Company to John Garo, September 27, 1937; Letter to Mr. Deming from Garo Studios, March 18, 1937; Letters from Garo Studios to Margaret Hackett, October 26, 1936, and December 15, 1936; Letter from John Garo to A. C. Shelton, April 14, 1937.

157. Letter from Herbert W. Jackson to John Garo, June 27, 1938; Letter to George Kelly from John Garo, December 9, 1935; *Christian Science Monitor*, January 3, 1938.

158. Letter from John Garo to Franklin I. Jordan, July 6, 1937; Letters from Frank Fraprie to John Garo, September 25, 1937; September 14, 1937; and September 17, 1937.

159. Statements of Edward Sliney and Company to John Garo, n. d.; Interview with John Garo Eresian, August 13, 2009; Tomajan and Eresian Family History, John Garo Eresian.

160. Letter from Manoog Dzeron to John Garo, April 20, 1937; Interview with Peter Zakarian by Ruth Thomasian, April 5, 1999; Letter from John Garo to Yousuf Karsh, February 12, 1937; Letter to Murphy and Peale from Garo Studios, July 23, 1936; Letter to Mr. Stokes from John Garo, July 31, 1936.

161. Letter to Mary Johnson and Bessie Papazian from John Garo, n. d.; Letter from Nelson Hood to John Garo, October 2, 1934; Letter from John Tomajan to John Garo, February 6, 1935; Letter from Nelson Hood to John Garo, March 5, 1935; Letters from John Tomajan to John Garo, February 8, 1935, and January 18, 1935; Letter from John Garo to Frances Eresian, December 9, 1936.

162. Inventory of Garo Studios, June 9, 1937; *Thirteenth Census of the U.S.*, 1910, Massachusetts, Suffolk County, Enumeration District 1603, 28A; *Fourteenth Census of the U.S.*, 1920, Massachusetts, Suffolk County, Enumeration District 384, 9A; *Fifteenth Census of the U.S.*, 1930, Massachusetts, Suffolk County, Enumeration District 13-641, 4B; E-mail from Sivang Sous to Mehmed Ali, September 6, 2010; Interview with John Garo Eresian, August 13, 2009.

163. Karsh, *In Search of Greatness*, 52; Tippett, *Portrait in Light and Shadow*, 64, 111; Letter from Yousuf Karsh to A. George Nakash, September 28, 1935; Letter from Yousuf Karsh to John Garo, May 8, 1939; *Ottawa Citizen*, January 25, 1961, 7; Letter from Yousuf Karsh to Frances Eresian, February 10, 1947.

164. Letter from Yousuf Karsh to George Nakash, January 30, 1940; Letter from Yousuf Karsh to Alice Garo, July 21, 1939; Letter from Yousuf Karsh to John Garo, May 8, 1939; Letter from Yousuf Karsh to George Nakash, March 12, 1939; Letter from Solange Karsh to Frances Eresian, October 16, 1950.

165. Letter from Solange Karsh to John Garo, (Yousuf Karsh Collection, Library and Archives Canada) July 14, 1936, R613 vol. 3, folder 18.

166. Letter to Pirie MacDonald from John Garo, July 15, 1935; Letter from John Garo to Frances Eresian, March 9, 1937; *Boston Herald*, June 13, 1937, sec. D.

167. Letter from Alice Garo to Yousuf and Solange Karsh, May 10, 1939; Letter from Alice Garo to Yousuf Karsh, June 4, 1939; Tomajan and Eresian Family History, John Garo Eresian; Karsh, *In Search of Greatness*, 38.

168. Karsh, *In Search of Greatness*, 38; Letters from Yousuf Karsh to Alice Garo, May 23, 1939, and July 21, 1939; Letter from Alice Garo to Yousuf Karsh, June 25, 1939.

169. Letters from Alice Garo to Yousuf Karsh, August 12, 1939; August 17, 1939; and October 17, 1939.

170. Canadian National Telegram from Alice Garo to Yousuf Karsh, October 31, 1939; Letter from Yousuf Karsh to John Garo, March 29, 1938.

171. *Hairenik*, November 3, 1939; *Boston Evening Transcript*, November 1, 1939; E-mails from Elise Cerigna, September 4, 2010, and September 7, 2010; Letter from Yousuf Karsh to Frances Eresian, February 10, 1947.

172. Letter from Yousuf Karsh to A. George Nakash, January 30, 1940.

173. Letter from Yousuf Karsh to Frances Eresian, February 10, 1947; Tomajan and Eresian Family History, John Garo Eresian; Interview with John Garo Eresian, August 13, 2009; *Boston Herald*, January 7, 1941, 17.

174. Hartmann, *The Valiant Knights of Daguerre*, 223; Letter from Yousuf Karsh to Frances Eresian, February 10, 1947.

CHAPTER 6

175. *Christian Science Monitor*, October 31, 1939, 13; *Boston Evening Transcript*, November 1, 1939, 20; *Boston Daily Record*, November 1, 1939, 13; *Boston Herald*, November 1, 1939, 23; *Boston Globe*, November 1, 1939, 17; *Boston Traveler*, November 1, 1939; *Baltimore Sun*, November 1, 1939, 18; *San Antonio Express*, November 1, 1939, 3; *Hairenik*, November 3, 1939, 1; Interview with Dr. Hagop Martin Deranian, September 4, 2009; *Christian Science Monitor*, March 5, 1942, 15; Boston Symphony Orchestra Concert Bulletin, 1941–1942, 819.

176. *American Photography* 45 (1951): 8.

177. Letter to Ada Greenberg from Robert Bretz, March 2, 1965; Tomajan and Eresian Family History, John Garo Eresian; E-mails from Bruce Papazian to Mehmed Ali, December 11, 2009, and January 3, 2010.

178. *Worcester Telegram and Gazette*, April 11, 1991, D4; Interview with John Garo Eresian, August 13, 2009.

179. *New York Times*, July 14, 2002.

180. *Globe and Mail*, September 26–27, 2008; Danziger and Conrad, *Interviews with Master Photographers*, 110; Interview with John Garo Eresian, August 13, 2009.

181. Letter from Solange Karsh to Frances Eresian, October 16, 1950.

182. Karsh, *Karsh: A Fifty-Year Retrospective*, 10; Karsh, *In Search of Greatness*, 38.

183. Letter from Yousuf Karsh to Frances Eresian, February 10, 1947.

184. Letter from John S. Tomajan to Yousuf Karsh, September 1, 1950; Letter from John S. Tomajan to Arthur Johnson, September 1, 1950; Letter from Joyce Large to Franklin "Pop" Jordan, November 20, 1954; Letter from John S. Tomajan to Arthur Johnson, September 1, 1950.

185. Karsh, *Karsh: A Fifty-Year Retrospective*, 9–10; Karsh, *In Search of Greatness*, 21–38; *Michigan Business Review* XVIII, no. 4 (July 1966): 1; Danziger and Conrad, *Interviews with Master Photographers*, 100–110; *Lenswork* 44 (December 2002–January 2003): 30–36; *Worcester Telegram and Gazette*, April 11, 1991, D4; *Popular Science* (October 1952): 222; "The Eyes Have It," *Photoicon* 5 (2008); Letter from Yousuf Karsh to Walter Frost, May 4, 1988; Interview with Estrellita Karsh, May 30, 2010.

186. Letter from Yousuf Karsh to P. K. Thomajan, May 4, 1951; Tomajan and Eresian Family History, John Garo Eresian.

187. Karsh, *In Search of Greatness*, 32; John H. Garo citation by Yousuf Karsh, n. d., 2; Letter to P. K. Thomajan from Joyce Large, secretary to Karsh, June 25, 1951; Letter from Yousuf Karsh to Eleanor Blaker, November 25, 1974.

188. Interview with Nazareth Gechijian by Ruth Thomasian, n. d.; Tomajan and Eresian Family History, John Garo Eresian; E-mail from John Kasaian to Mehmed Ali, August 24, 2009; John Eresian conversation with John Blaker, July 8, 2000; *Armenian Mirror-Spectator*, March 5, 1994, 10.

189. Interview with Estrellita Karsh, May 30, 2010; Letter from Yousuf Karsh to Frances Eresian, February 10, 1947; Letters from Franklin "Pop" Jordan to Yousuf Karsh, May 2, 1951, and October 30, 1954; Letter from Joyce Large to Franklin "Pop" Jordan, November 20, 1954; Letter from Franklin "Pop" Jordan to Yousuf Karsh, July 1, 1955; Letter from Yousuf Karsh to Franklin "Pop" Jordan, July 8, 1955; Letter from John Tomajan to Yousuf Karsh, December 26, 1961; Letter from Yousuf Karsh to John Tomajan, January 10, 1962; Letter from Yousuf Karsh to Frances Eresian, May 14, 1963; Letter from Yousuf Karsh to John Garo Eresian, August 8, 1967; Letter from Yousuf Karsh to John Eresian, September, 27, 1967; *Worcester Telegram and Gazette,* April 11, 1991, D4; Letter from Joyce Large to Puzant Kevork Thomajan, June 25, 1951.

190. Letter from Franklin "Pop" Jordan to Yousuf Karsh, July 1, 1955; Interview with Estrellita Karsh, May 30, 2010; Letter from Yousuf Karsh to George Brown, December 10, 1974; Letter from Francis E. Wylie to Yousuf Karsh, April 20, 1972.

191. *Worcester Telegram and Gazette*, April 11, 1991, D4; Letter from Yousuf Karsh to George Tice, June 20, 1975; Letter from George Kelley to Yousuf Karsh, January 10, 1972.

192. Interview with Estrellita Karsh, May 30, 2010; Letter from Yousuf Karsh to John Eresian, September, 27, 1967.

193. Letter from Yousuf Karsh to George Brown, December 10, 1974; "Musings and Rambling of J&C Imaging," Blogspot, March 17, 2010; Letter from John Eresian to Estrellita Karsh, June 27, 2000; Letter from John Garo Eresian to Yousuf Karsh, January 23, 1975; Letter from Yousuf Karsh to Eleanor Blaker, November 25, 1974.

194. Letter from George W. Brown to Herbert Kelpen, April 30, 1975; Interview with Estrellita Karsh, May 30, 2010.

195. Letter from John Garo Eresian to Yousuf Karsh, January 23, 1975; Interview with Estrellita Karsh, May 30, 2010; Letter from Eleanor Blaker to Yousuf Karsh, March 12, 1975.

196. Letter from Lawrence W. Blaker to Yousuf Karsh, January 12, 1979; Letter from Eleanor Blaker to Yousuf Karsh, May 24, 1988; Letter from Lawrence W. Blaker to Yousuf Karsh, March 15, 1979; Interview with Estrellita Karsh, May 30, 2010.

197. Letter from Yousuf Karsh to Eleanor Blaker, October 5, 1988.

198. Letter to Mrs. Samuel Payson from Garo Studios, July 19, 1935; Letter to Mrs. Lewis W. Mustard Jr. from Garo Studios, June 19, 1935.

199. Interview with Estrellita Karsh, May 30, 2010; Yousuf Karsh and Jerry Fielder, *Karsh: A Biography in Images* (Boston: MFA Publications, 2003), 15; Interview with Estrellita Karsh, January 10, 2012; *Boston Globe*, September 23, 2008.

200. *Karsh: A Biography in Images*, 15; Festival Karsh Ottawa brochure, Library and Archives Canada, 2009; Interview with John Garo Eresian, January 8, 2012.

IMAGE CREDITS

Front Cover: Garo and Karsh: Karsh Estate

Back Cover: John H. Garo, by Yousuf Karsh: Karsh Estate

Page viii: Estrellita Karsh, by Yousuf Karsh: Karsh Estate

Page xi: John H. Garo, by Yousuf Karsh: Karsh Estate

Page xii: John Garo, Library and Archives Canada

Page 1: John H. Garo: Library and Archives Canada, e011161875

Page 3: George Nakash, Self-portrait: Karsh Estate

Page 4: Early Landscape by Yousuf Karsh: Karsh Estate

Page 6: "Portrait," by John Garo, *Photo Era, The American Journal of Photography*: Library and Archives Canada, e011161891

Page 7: Self-portrait, by Yousuf Karsh: Karsh Estate

Page 8: "Untitled," by John Garo, *Yearbook of the Photographers' Association of New England*, Bridgeport Convention: Library and Archives Canada, e011161866

Page 9: Karsh's collection of Garo's photographic brushes: Canada Science and Technology Museum Canada Science and Technology Museum

Page 9: *Wilson's Photographic Magazine* cover: Library and Archives Canada, e011161892

Page 9: *Photo-Era* cover: Library and Archives Canada, e011161895

Page 9: *Yearbook* cover: Library and Archives Canada, e011161893

Page 9: *American Photography* cover: Library and Archives Canada, e011161894

Page 10: Corner of John H. Garo's studio: Boston Public Library, Courtesy of the Trustees of the Boston Public Library.

Page 11: Self-portrait, by John Garo: Library and Archives Canada, e011161897

Page 12: "Simplicity" by John Garo: Museum of Fine Arts, Boston

Page 12: "Turban," portrait of Betty Low by Yousuf Karsh: Karsh Estate

Page 13: Unknown subject by John Garo: Library and Archives Canada, e011161874

Page 13: Gladys Harlan Tomajan, by John Garo: Library and Archives Canada

Page 14: Yousuf Karsh, by Ivan Dmitri: Karsh Estate

Page 15: Winston Churchill, by Yousuf Karsh: Karsh Estate

Page 16: Princess Grace of Monaco, by Yousuf Karsh: Karsh Estate

Page 17: Yousuf Karsh and Ansel Adams, Yosemite: Karsh Estate

Page 18: Self-portrait, by John Garo: Library and Archives Canada – Eresian Collection, e011161863

Page 19: Yousuf Karsh: Karsh Estate

Page 20: Albert Einstein, by Yousuf Karsh: Karsh Estate

Page 21: Pablo Picasso, by Yousuf Karsh: Karsh Estate

Page 22: Nelson Mandela, by Yousuf Karsh: Karsh Estate

Page 24: Portrait of John H. Garo taken at Purdy Studio: Library and Archives Canada, e011161885

Page 26: Village of Parchanj: General history (1600–1937). Drawn by M. B. Dzeron February 1932. Joliet, Illinois.

Page 29: A young Mgurdich (in fez on right) with siblings: Dr. H. Martin Deranian Collection

Page 32: "Self-Portrait," by John H. Garo: Library and Archives Canada – Eresian Collection, e011161863

Page 34: "Self-Portrait," painting by John Garo: Armenian Museum and Library of America – Watertown. "Self-Portrait," by John Garo was donated by John and Van Erasian to the Armenian Museum of America.

Page 36: Early example of Garo's watercolors and oil paintings: Library and Archives Canada, e011161889

Page 37: Garo's early sketches: Library and Archives Canada and Library and Archives Canada – Eresian Collection, R13841, vol. 4., c011161864, e011161890

Page 40: Portrait of John Garo, by Elmer Chickering: Library and Archives Canada – Eresian Collection, e011161869

Page 41: "Father Fauvent, " by John Garo: *The Photographic Times*, Volume XXXIV, Number 1, January 1902, p. 23

Page 41: "Monsieur Thénardier," by John Garo: *The Photographic Times*, Volume XXXIII, Number 12, December 1901, p. 580

Page 43: Malvina Longfellow (in character with dagger), by John Garo: Prints & Photographs Division, Library of Congress, LC-DIG-ds-07524

Page 44: "Bubble," by John Garo: Worcester Art Museum, Worcester, Massachusetts. John Garo, 2008.9

Page 45: "Art Study from Model," by John Garo: Harvard Art Museums/ Fogg Museum, Transfer from the Carpenter Center for the Visual Arts, 2.2002.644. Copyright: Photo: Imaging Department © President and Fellows of Harvard College

Page 47: *Wilson's Photographic Magazine* cover: Library and Archives Canada, e011161892

Page 47: Garo's signature studio emblem: Museum of Fine Arts, Boston

Page 48: The Boylston Chambers Building: American Architect and Building News, June 27, 1903, Volume 80, Number 1453, pp. 102–110

Page 49: "Portrait," by John Garo, *Photo Era, The American Journal of Photography*: Library and Archives Canada, e011161891

Page 51: Unknown subject by John Garo: Library and Archives Canada, e011161874

Page 52: "Twilight," by John Garo: Worcester Art Museum, Worcester, Massachusetts. John Garo, 2008.11

Page 53: "Cavalier" by John Garo: Library and Archives Canada

Page 55: "The Flower Girl," by John Garo: Library and Archives Canada, e011161888

Page 56: Portrait of Unidentified Man, by John Garo: Museum of Fine Arts, Boston

Page 58: Self-portrait, by John Garo: Library and Archives Canada, e011161897

Page 61: "Flood," color photograph by John Garo: Museum of Fine Arts, Boston

Page 62: Wollensak Advertisement from *Photographic Review*: Photographic Review, Volume 26, Number 1, January 1920, p.14

Page 66: *Yearbook of the Photographers' Association of New England*, Bridgeport Convention: Library and Archives Canada, e011161867

Page 71: "Portrait Study Number 2," by John Garo: *Complete Self-Instructing Library of Practical Photography: Studio,* by the American School of Art and Photography (Scranton, PA)

Page 73: "Italian Flower Girl," by John Garo: Library and Archives Canada – Eresian Collection, e011161868

Page 75: "Bubble," by John Garo: Museum of Fine Arts, Boston

Page 76: "Portrait Study," by John Garo: Courtesy of George Eastman House, International Museum of Photography and Film

Page 77: Portrait of Hope Steizle Merrill, by John Garo: Schlesinger Library, Radcliffe Institute, Harvard University

Page 78: Garo's portrait of Billie Burke: *Photo-Era Magazine,* Volume XXV, July 1910, Number 1, Page 2

Page 80: "Woman Seated in Hat," by John Garo: Museum of Fine Arts, Boston

Page 81: Geraldine Farrar, by John Garo: Prints & Photographs Division, Library of Congress, LC-DIG-ds-07522

Page 82: Eugene Foss, by John Garo: Harvard Art Museums/Fogg Museum, Transfer from the Carpenter Center for the Visual Arts, Transferred from the Fogg Art Museum, 2.2002.586. Copyright: Photo: Imaging Department © President and Fellows of Harvard

Page 83: George Bartlett, by John Garo: Harvard Art Museums/Fogg Museum, Transfer from the Carpenter Center for the Visual Arts, 2.2002.817. Copyright: Photo: Imaging Department © President and Fellows of Harvard College

Page 84: "Untitled," by John Garo, *Yearbook of the Photographers' Association of New England,* Bridgeport Convention: Library and Archives Canada, e011161866

Page 86: Cardinal William Henry O'Connell, by John Garo: Prints & Photographs Division, Library of Congress, LC-USZ62-104061

Page 87: Edith Nourse, by John Garo: Schlesinger Library, Radcliffe Institute, Harvard University

Page 88: Portrait of a young boy, by John Garo: Museum of Fine Arts, Boston

Page 89: Russell Tomajan, by John Garo: Library and Archives Canada, e011161881

Page 90: Portrait of Edward Everett Hale, by John Garo: Courtesy of Tyler James Papazian/Bruce Papazian Collection

Page 91: Wedding portrait of Juan Ramon Jimenez and Zenobia Camprubi, by John Garo: Juan Ramón Jiménez Foundation and House Museum – Moguer, Spain

Page 92: Calvin Coolidge, by John Garo: Prints & Photographs Division, Library of Congress, LC-DIG-ds-07523

Page 93: Portrait of photographer Nussbaum, by John Garo: Library and Archives Canada, e011161884

Page 95: "Art study from model," by John Garo: Harvard Art Museums/ Fogg Museum, Transfer from the Carpenter Center for the Visual Arts, 2.2002.585. Copyright: Photo Imaging Department ©President and Fellows of Harvard College

Page 96: Portrait of Tenor Roland Hayes, by John Garo: Courtesy of the E. Azalia Hackley Collection of African Americans in the Performing Arts, Detroit Public Library

Page 98: "Self-Portrait," by John Garo: Courtesy of the Trustees of the Boston Public Library

Page 100: Untitled, by John Garo: Library and Archives Canada – Eresian Collection, e011161873

Page 101: Dean LeBaron Russell Briggs, by John Garo: Harvard University Archives

Page 102: "Blue Ribbon," by John Garo: Museum of Fine Arts, Boston

Page 103: Portrait of John S. Tomajan, by John Garo: Library and Archives Canada, e011161870

Page 104: Ralph Adams Cram, by John Garo: Harvard Art Museums/Fogg Museum, Transfer from the Carpenter Center for the Visual Arts, 2.2002.831. Copyright: Photo Imaging Department © President and Fellows of Harvard College

Page 105: Charles Tomajan family, by John Garo: Library and Archives Canada, e011161871

Page 107: Gladys Harlow Tomajan, by John Garo: Library and Archives Canada, e011161883

Page 108: Russell Tomajan, by John Garo: Library and Archives Canada, e011161880

Page 108: Uncle Garo with little John Garo Eresian: Library and Archives Canada, e011161886

Page 109: Pierre Monteux, by John Garo: Courtesy Boston Symphony Orchestra Archives (Pres 86-10 f1.03)

Page 109: Laurent Torno, by John Garo: Harvard Art Museums/Fogg Museum, Transfer from the Carpenter Center for the Visual Arts, 2.2002.830. Copyright: Photo Imaging Department © President and Fellows of Harvard College

Page 111: Portrait of Reverend William Van Allen, by John Garo: Harvard Art Museums/Fogg Museum, Transfer from the Carpenter Center for the Visual Arts, 2.2002.827. Copyright: Photo Imaging Department © President and Fellows of Harvard College

Page 114: Halloween party at Garo Studios: Library and Archives Canada, e011161879

Page 115: Costume party at Garo Studios: Library and Archives Canada – Eresian Collection, e011161872

Page 117: Portrait of Rose Davidian, by John Garo: Library and Archives Canada – Eresian Collection, e011161865

Page 120: Portrait of John Garo, by William Manahan: Manahan-Phelps-McCulloch Photographic Collection, Hillsborough Historical Society

Page 123: "Young Blonde Girl," by John Garo: Photographic Control Processes, Franklin I. Jordan, Galleon Publishers, 1937, page 138

Page 125: "Study #1," by John Garo: Worcester Art Museum, Worcester, Massachusetts: John Garo, 2008.12

Page 127: "Miss R," by John Garo: Library and Archives Canada, e011161878

Page 128: "Oval Portrait of a Woman," by John Garo: Museum of Fine Arts, Boston

Page 136: Portrait of John Garo and Solange Karsh, by Yousuf Karsh: Karsh Estate

Page 139: George Bartlett, by John Garo: Library and Archives Canada, e011161887

Page 142: Self-portrait, by John Garo: Library and Archives Canada, e011161882

Page 145: "Portrait," by John Garo, *Photo-Era, The American Journal of Photography*: Library and Archives Canada, e011161877

Page 147: Clarence Barron, by John Garo: New York Times

Page 148: "The Silver Band," by John Garo: Library and Archives Canada, e011161876

Page 150: Max Fiedler, Music Director, by John Garo: Courtesy Boston Symphony Orchestra Archives (Pres 86.6_Folio_01)

Page 153: "Facade of the Boston Art Museum," by John Garo: Worcester Art Museum, Worcester, Massachusetts. John Garo, 2008.10

Page 158: "Still life, desk," by John Garo: Museum of Fine Arts, Boston